WESTERN

SKIES

DARDEN

SMITH

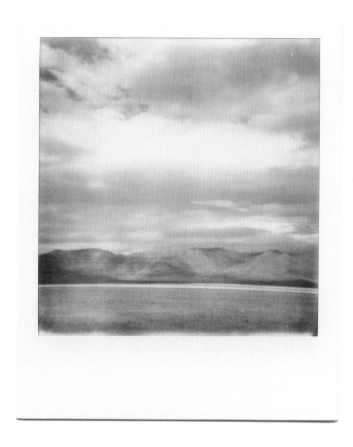

WESTERN SKIES
DARDEN SMITH

FOREWORD BY RODNEY CROWELL

DEXTERITY
NASHVILLE

Dexterity, LLC
604 Magnolia Lane
Nashville, TN 37211

First edition: 2022
10 9 8 7 6 5 4 3 2 1

ISBN: 9781947297425 (Hardcover)
ISBN: 9781947297432 (E-book)
ISBN: 9781947297449 (Audiobook)
ISBN: 9781947297494 (Limited Edition)
ISBN: 9781947297500 (Limited Edition Box)

Publisher's Cataloging-in-Publication Data

Names: Smith, Darden, author. | Crowell, Rodney, foreword author.
Title: Western skies / Darden Smith; foreword by Rodney Crowell.
Description: Nashville, TN: Dexterity, 2022.
Identifiers: ISBN: 978-1-947297-42-5 (hardcover) | 978-1-947297-43-2 (ebook) |
978-1-947297-44-9 (audiobook)
Subjects: LCSH West (U.S.)--Pictorial works. | West (U.S.)--In art--Pictorial works. |
West (U.S.)--Poetry. | BISAC PHOTOGRAPHY / Individual Photographers /
Essays | MUSIC / Essays | PHOTOGRAPHY / Subjects & Themes / Regional |
TRAVEL / United States / South / West South Central (AR, LA, OK, TX)
Classification: LCC F595.3 .D37 2022 | DDC 779/.9978--dc23

Book and cover design by Pentagram.

All photography by Darden Smith.
Front cover photograph title: *Rodeo*
Back cover photograph title: *Dry Marsh*

CONTENTS

TO DOWNLOAD THE WESTERN SKIES ALBUM
+ AUDIO VERSIONS OF THE WRITINGS, GO TO
WWW.DARDENSMITH.COM/WESTERNSKIES

FOR BILL WORRELL

FOREWORD

BY RODNEY CROWELL

Western Skies is a near perfect multimedia balancing act performed by poet, essayist, photographer, singer and songwriter, Darden Smith. It's the kind of work that could, and should, bring him recognition as one of the Lone Star State's finest land-and-skyscape artists. His prose poems put me in mind of Elroy Bode, the Kerrville-born El Paso high school English teacher, whose notebook meditations on what he termed "commonplace mysteries" abundant in his sparsely populated corner of the world known as West Texas are arguably worth mentioning in the same breath as Larry McMurtry. Like Bode, Smith is a keen observer. He identifies narrative gems hidden in plain sight and gifts the reader with their singular experience. His polaroid images portray a stark reality associated with the likes of Depression-era photographers Arthur Rothstein and Dorothea Lange. And his songs are a deft blend of melancholy (reminiscent of Jackson Browne's early work) and the no-nonsense virtue of vintage JJ Cale. A most effective combination.

Hopefully such comparisons serve their descriptive purpose; however, I must say that it's Darden Smith's close-to-the-ground spirituality that gives the songs, poems and photographs their contemplative dignity. His willingness to venture unaccompanied into what others might describe as nothing more than a vast emptiness invites, and indeed inspires, the listener/reader/viewer to be gratefully alone with their thoughts. Having experienced *Western Skies* as a whole, I found myself thinking, and feeling, these things: *there's a whole lot of God out there in that godless wasteland, and it's only by embracing our aloneness that we experience the oneness of all creation.* Thanks to one man's clear-eyed vision, there's a world within a world that can now belong to us all. An artist's job well done, Mr. Smith. I bow in earnest.

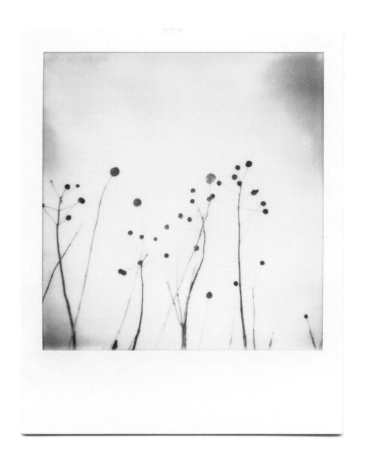

THISTLE

PREFACE

Western Skies started with the photographs, all of them taken with an old Polaroid camera resurrected from a box in my garage sometime in the summer of 2020. I don't think of myself as a photographer, but I sure like to take pictures. The idea of using such an outdated way of capturing images struck me as the perfect antidote to the hectic digital nature of these times. My usual way of working was to see something, stop the car, take the photo then immediately get back in and drive off, letting it develop in a box on the front seat as the miles clicked over. I had one shot, maybe two, for each idea and there were many, many mistakes. Part of the joy was the randomness of it, and having almost zero control over how the image came out. It's kind of a ridiculous and expensive way to work. Each shot cost about as much as a good espresso, so that became my calculator: was this picture worth a coffee? If not, I'd just walk away. After a time, I found myself not taking almost as many photos as I did.

The songs came together as the months of the pandemic wore on. Some are new, others were older pieces of things that I reworked. Both "Los Angeles" and "Western Skies" were based on lyrics that had been hiding in my piano bench for a decade or so. The essays began as a collection of random thoughts and observations scribbled in a notebook during my travels.

It was only during a three-day recording session at Sonic Ranch in Tornillo, Texas, with just myself and an engineer, Mario Ramirez, that I could see how the project worked as a whole. It occurred to me as I was standing outside watching the dusk settle on the pecan groves surrounding the studio on the last night of recording that the three parts hung together as one. And it was a book. With music. Before that it was just a bunch of songs, a box of photos and a notebook.

I'm very grateful to everyone who worked on *Western Skies*, including Mario at Sonic Ranch, who was key to my getting the songs down in the first place. Michael Ramos and Stewart Lerman are both longtime music collaborators of mine, and they not only kept me between the ditches, but accommodated my crazy ideas while constantly pushing me beyond my usual patterns of working. DJ Stout at Pentagram was one of the first people I talked to about *Western Skies*. It was an easy sell. Bringing Stu Taylor in as the lead designer was a great call, not only because he's good at what he does, but also because he makes me laugh, which is very important. And without Matt West at Dexterity Books, none of this would've happened. He understood from the very first conversation, of which there have been many, what I had in mind. And finally, Haley Rushing, who puts up with me, encourages me, and welcomes me back home when I've been running around out in the desert for a couple of weeks.

Texas, and the American Southwest in general, is a big, beautiful place. There's a lot to love about it. And then there's the other part, which makes me shake my head in wonder. *Western Skies* isn't "about" anywhere in particular. It's a love song to the mythology of Texas. Not the heroic, Wild West version, but the one that lives only in my head. I've spent a long time looking at it, and thankfully I wrote a few things down.

8.27.21
AUSTIN, TEXAS

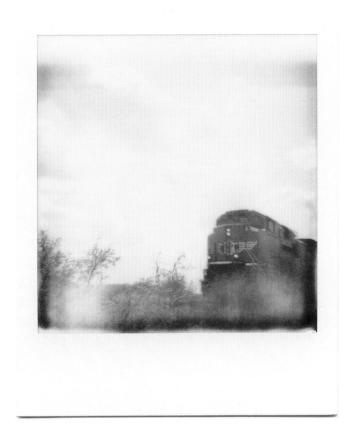

ENGINE

CINEMA SKY

I think about the great contrasts here.
Ghosts, heroes, love and danger are ever present.
Parking lot upon parking lot signals a profound transience.
Cloud and blue-sky sparkle in shattered glass along the roadside.
Though it may look blown out and spent, the land itself is alive.
Trash filled verges blend into unbroken horizon.
What seems to be open plain is in fact fenced and deserted.

The architecture of the arid towns
Wears the shadow of an optimistic glory,
But one that is long past.
Gas stations, fireworks stands and souvenir shops
Stand counter to the cinema sky and sweet smell of rain
On those rare occasions when the ground is worthy of its falling.

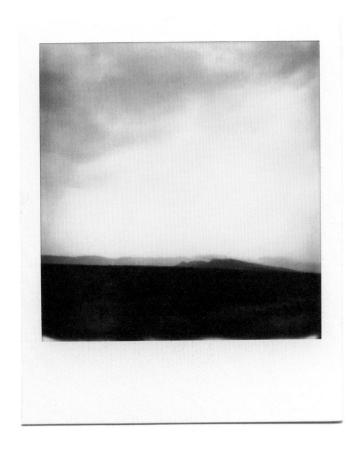

MARATHON

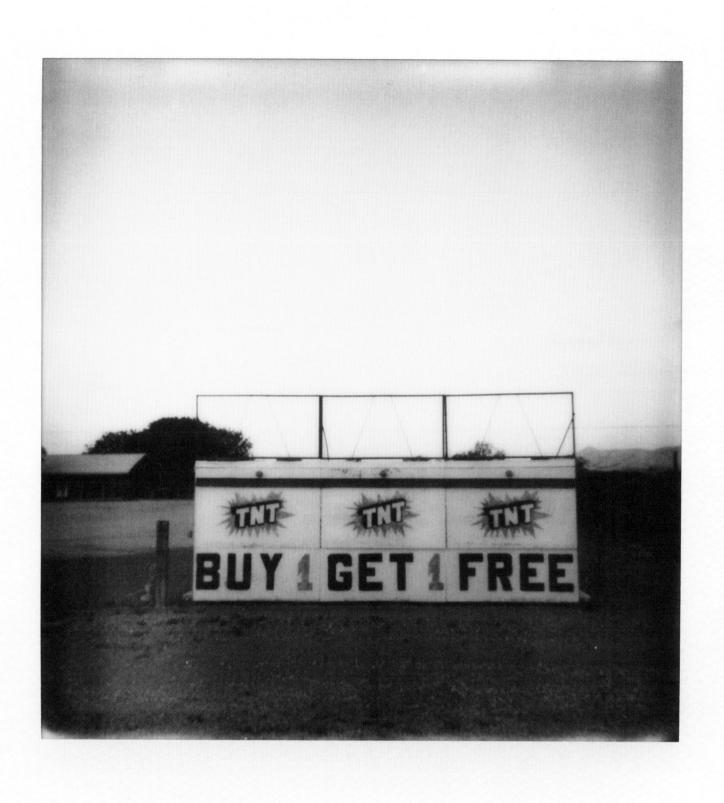

TNT

Lately I been wishing that the world was flat
Walk out to the edge let that be that
Fly through the sunshine looking for rain
Why is everybody thinking I'm insane

Lately every time that I open my mouth
Somebody says something stupid and a fight breaks out
Somebody gonna fall now who's it gonna be
Lately everybody keeps looking at me

'Cause there's miles between all I see
Inside my dream and reality
There's too much noise, I lose my voice
Make me want to walk out in the desert at night and scream
I'm lost in the miles between

Lately I don't want to open up my heart
It hurts when it's over, hurts when it starts
I admit it I'm addicted to walking on a wire
Don't tell me about the net, baby let's get higher

'Cause there's miles between what you see
Inside my dream and reality
There's too much noise, I lose my voice
Silence in the middle of the night is deafening
I'm lost in the miles between

It really don't matter if it's round or flat
I want to spin off the edge and never come back
Float to the bottom of the deep blue sea

'Cause there's miles between all I see
Inside my dream and reality
There's so much noise, I lose my voice
Still I keep talking and hoping that you're listening
Still I keep talking, hoping that you're listening
I'm lost in the miles between

DARDEN SMITH / JACK INGRAM
DARDEN SMITH MUSIC (ASCAP) / BEAT UP FORD (BMI)

STORM

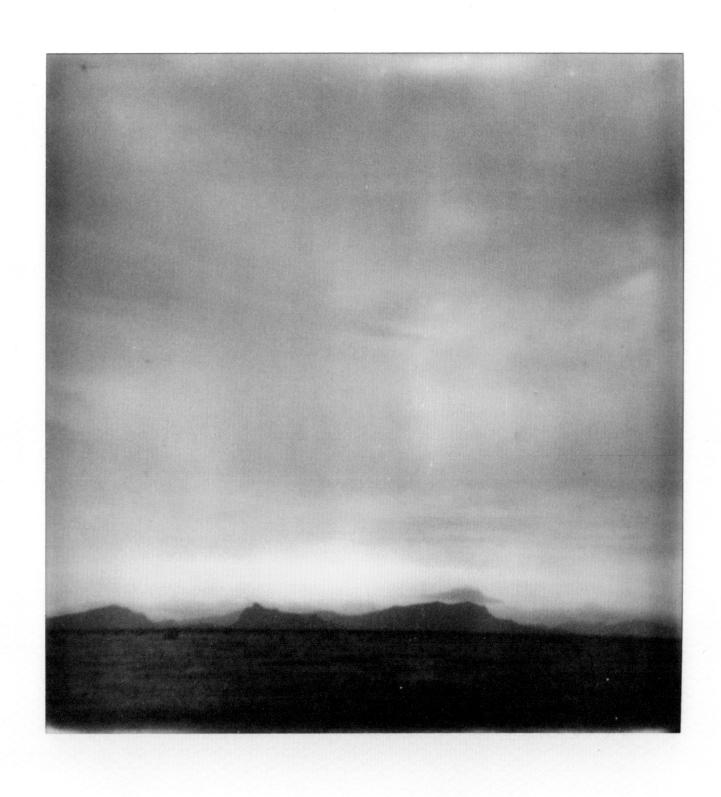

A PLACE OF NO MARKIN

I take these drives, collect these photographs, listen to stories
from those further down the path, let the myth of the land
and the people wash through me, stand beside tracks and
play guitar as trains thunder past, feel sand blowing against
my skin, go out past the lights to see constellations hang in
the sky, move beyond fence lines and lie down among stones,
get lost in a place of no markings, walk alone into the night,
stumble to my knees, feel the wind on my face as a distant
coyote calls and the night bird answers, and fix my eyes on
a mark somewhere between the stars to whisper your name.

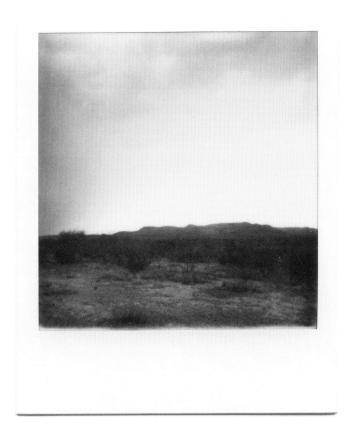

BROKEN GROUND

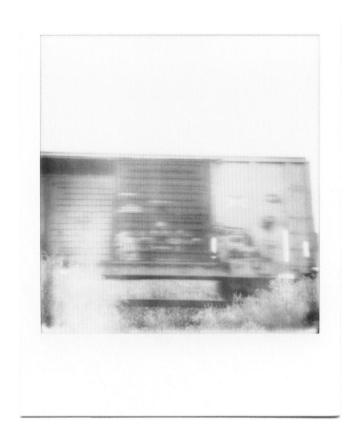

MOTION

BONES

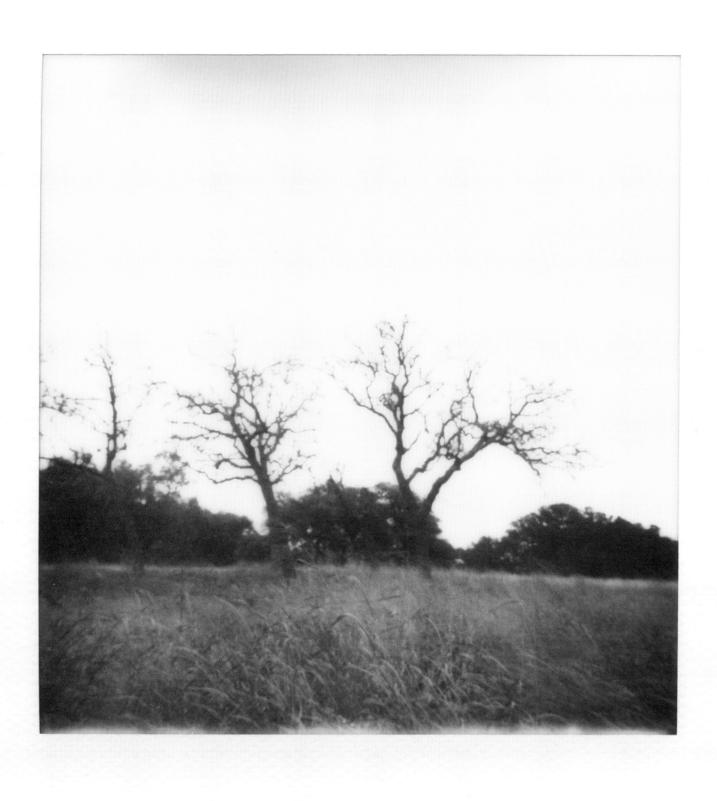

BLU

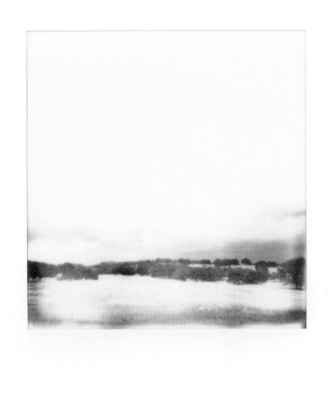

CASTELL

JESTEM

In the granite and limestone cuts
Of rivers and creeks sloping
Their way towards the gulf
Lay the little towns with their staked claims
Against the dust and wind

The great empty well scars mark the effort
To pull dreams out of the earth
Dams and interstates draw fitful lines
Of advance and retreat
In our running battle to reshape God
Into something closer to our own liking
But I see the ever-land of
Horse, sky, unbroken prairie
Believers and dispossessed
Scattered like the devil's own mercury
Across this wordless evening

And I want to go back, back
Beyond all this marching
To before we came and broke this ground
And the bluestem ran like first light
Across your face

When only birdwings filled the sky
And we did not yet know
The curve of the earth.

IRAAN

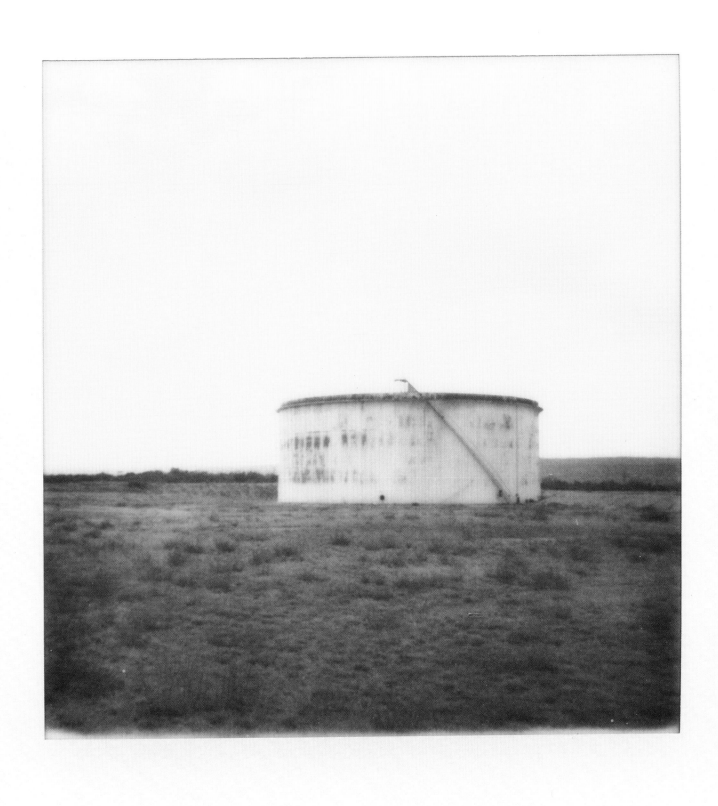

02 RUNNING OUT OF TIME

There ain't nothing funny about getting older
My soul aches, my body feels the strain
The past sits heavy on my shoulder
Tomorrow comes on like a train
If these days are really numbered
If there's an end to the line
Then I'm gonna love you like I'm running
Like I'm running out of time

I count the days that I have wasted chasing
Some vision of what I thought I should be
It's just another green grass story
I thought it was freedom, it was chains without a key
If these nights are really numbered
If there's an end to the wine
Then I'm gonna love you like I'm running
Like I'm running out of time
I'm gonna love you like I'm running
Like I'm running out of time

Warm wind off the Gulf Coast tonight
A baby powder moon is in the sky
You and me laying here talking about nothing
I see that sparkle in your eye
I know these moments they are numbered
So I'm not gonna let it pass us by
I'm gonna love you like I'm running
Like I'm running out of time
Yes I'm gonna love you like I'm running
Like I'm running out of time

DARDEN SMITH
DARDEN SMITH MUSIC (ASCAP)

END OF TRACK

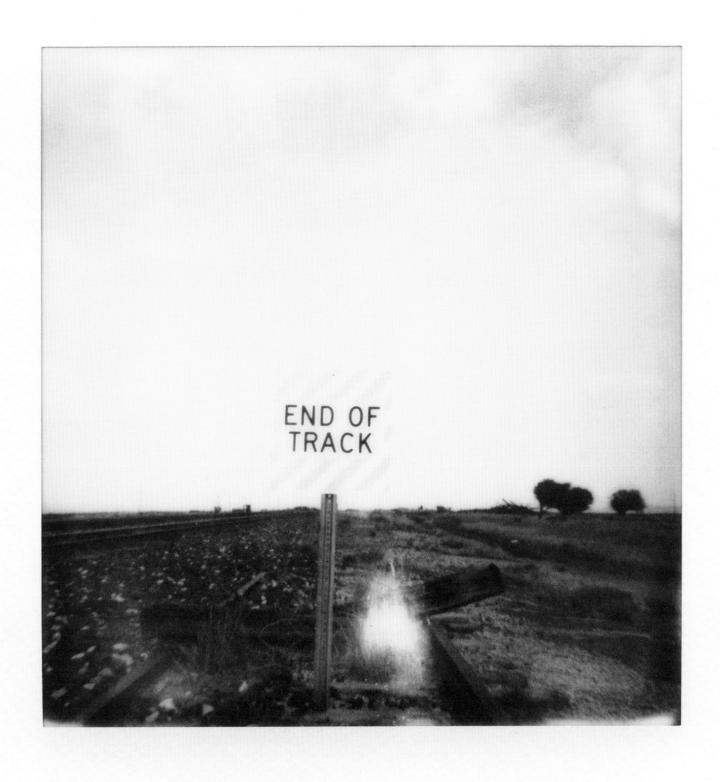

THE OCEAN THE DE

All of this used to be underwater.
From the freeway tangles of Houston and Dallas
Across Austin to El Paso
Volcanic explosions shifted plates
And a star or two surely burrowed its way through.

Year upon muddy year the withdrawing currents
Left behind layers of limestone cake
To hold fast the remains of creatures and plants
Vaguely familiar but of another world,
Like faded photographs of family
Too many generations back
Whose names no one remembers.

Wind, rain, storm followed
And the new water, itself remnant of the old
Gathered by torrents in the low places
Pushing sand and rock through the traces in the tilt
Leaving only void in its wake.
As plate earth yielded to the first cracks and
Downward breaks of and for this migration,
Lava drains, tectonic violence,
Stones and blown sediment left the land scarred,
Separated into mesa, table and canyon,
Where vast swaths of water drifted towards
Ever bigger drainage
And the hungry streams, fickle to the point of violence,
Retreated into bitter silence with the flood's passing.

Wide herds moved through these valleys
And across the high flats.
Where mesquite and juniper now cling to the bleached ground
Topsoil held tall grass and hardwoods.
People on foot, horseback, entire civilizations
Migrated through here and on,
Driven by hunger, desire, war and the pulse of seasons.

On the rise and fall of the blacktop wave
The lines on the walls move by
At eighty miles an hour
Each holding a thousand, a million years.
I stop and the silence wraps around me.

Standing on a rise looking down on the valley of the Pecos
A great loneliness comes
Calling from horseback riders,
Pursuers and pursued
At home in the place of no home,
Where stars on their mystic roll
Through and above cloud and moon
Night after night, day upon day,
Flower to prairie fire,
Ocean tide to fragile streambed
Know there is nothing permanent,
And that one day all of this—
Every shell, shadow and road—
Will again be submerged.

UNDER SERT

For this is the way of truth.
We think the way we see it now
Is as it's always been.
We yearn in our mind, in our walls, bridges,
Houses and laws, songs and sex
For some lasting place,
Something that says forever.

While in the voice of a dodging crow
I hear the whisper truth
That I am nothing compared to rock,
That I and everything I do and think
Will one day be dust
Moving through the unseen lowland,
On the back and in the belly
Of some new and fearsome storm.

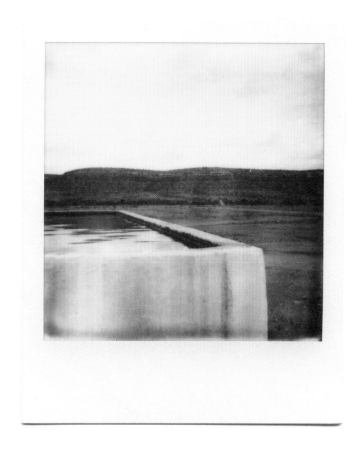

TANK #1

FLOOD

BULL

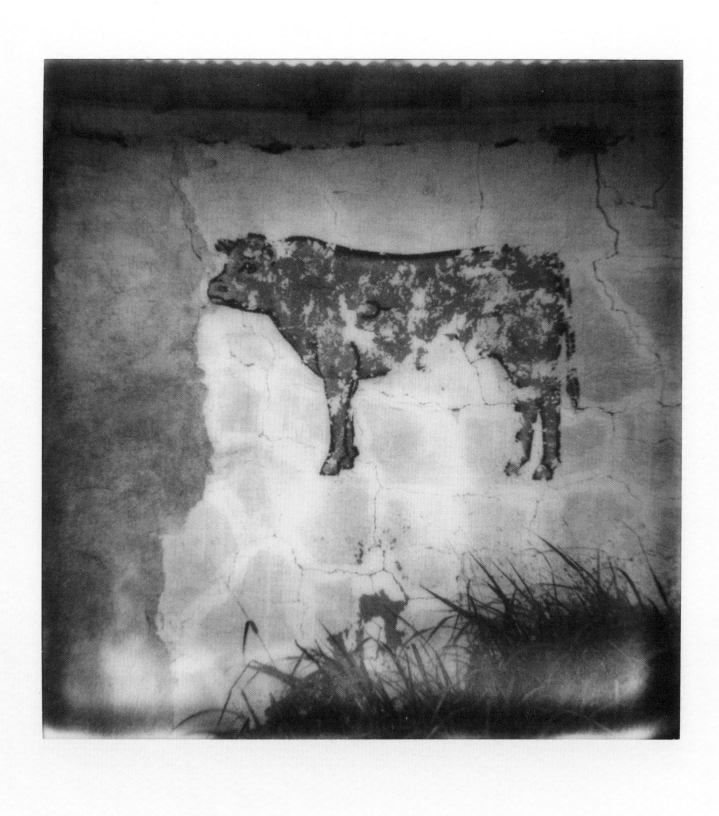

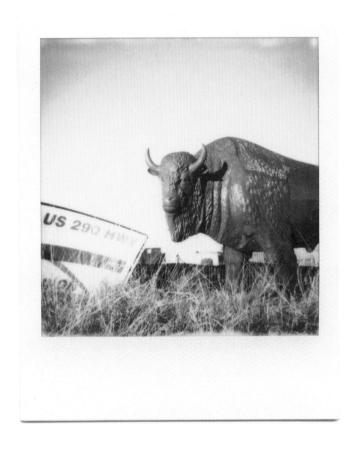

290

THE SIGNS OF OTHERS

No matter how far I go
Out past highway and streetlight
There are signs of others
Who have come this way
And are now drifting
Among the shadows of my stories

As I move down these trails
Eyes skirting horizon lines
Reflected on rocks
Fallen from stars
Lilting through reeds
In slow-moving water
That drains this land
I am guided by their
Echoing songs

For in the great open
I too am called to write my name
Across the cloudless sky
So that years from now
A child out wandering a hidden trail
Singing a melody that only they can cipher
Might stumble upon the mark
Sensing this path too
Was once walked upon
And they are not
Alone

BROKEN TEEPEE

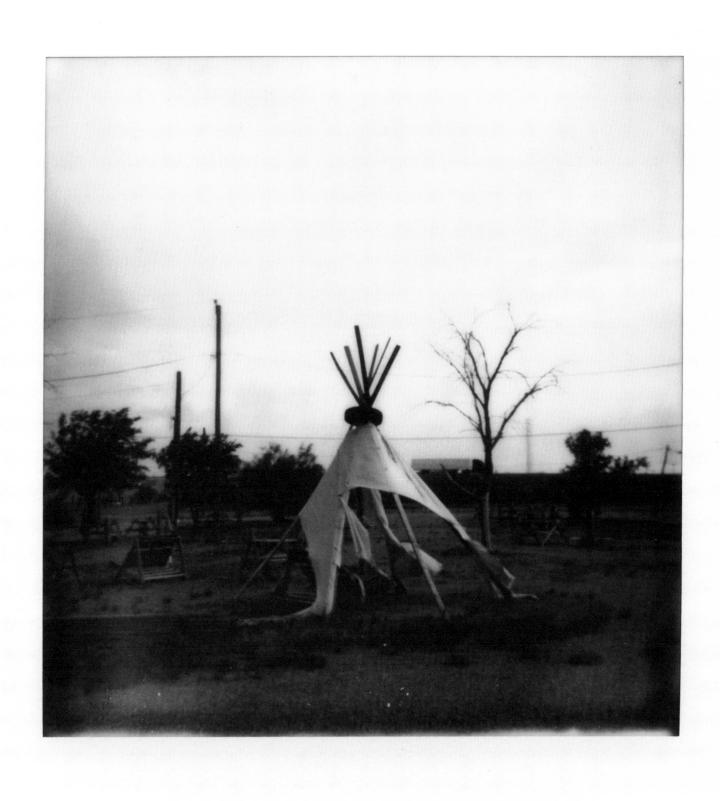

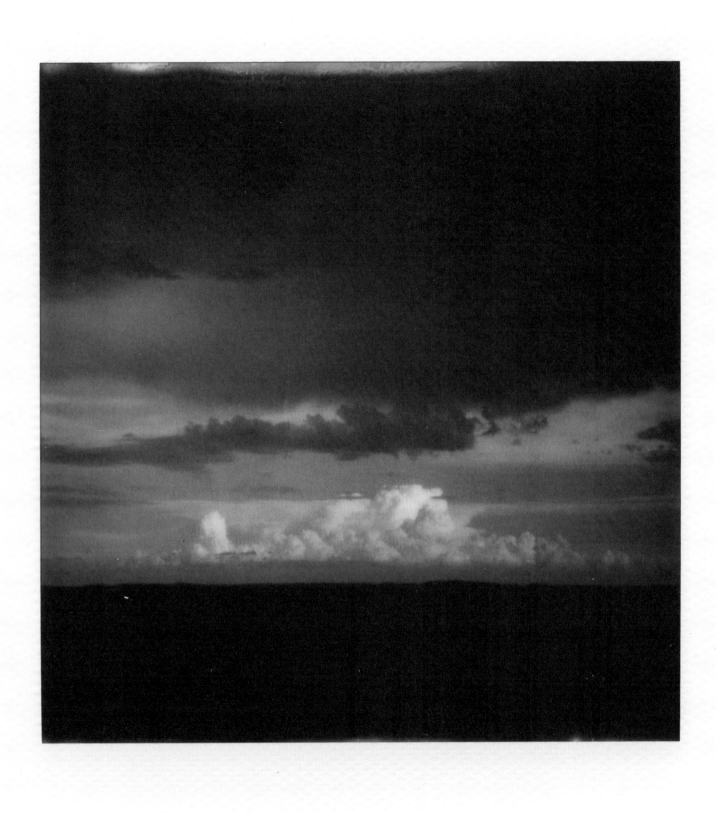

03 WESTERN SKIES

Storm is blowing in and window is open wide
We lay there like two loaded guns
I will always think of you in that fading light
Your silhouette a river I would run

And the stars they are falling from your eyes
And my love, my love was on the rise
And I am in between you and some horizon line
Underneath the western skies

And the stars they were falling from your eyes
And my love, my love is on the rise
And I am in between you and some horizon line
Underneath the western skies

Time is not the only thing that flies for us now
The heart is not the only thing that breaks
Your memory is all that keeps my feet upon this earth
The truth is just a train that came too late

And the stars they are falling from your eyes
And my love, my love is on the rise
And I am in between you and some horizon line
Underneath the western skies
And I am in between you and some horizon line
Underneath the western skies

DARDEN SMITH
DARDEN SMITH MUSIC (ASCAP)

SOUTH FROM 2810

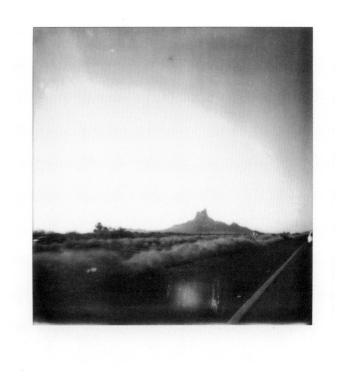

PICACHO

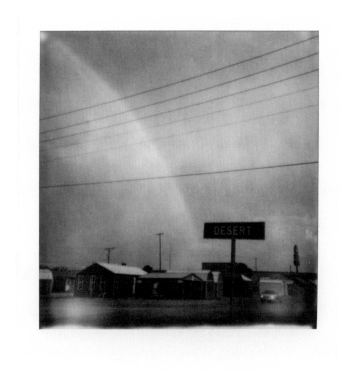

DESERT

ECKLACE

From this distance
It's all promise and imagined romance,
Lights stretched out like a necklace
Across the desert's black skin.

Just after the first gas station coming into town,
I see abandoned oil rigs, houses with dirt and cactus front yards,
Hear barking dogs and the thump of distant norteño.
Bits of an old blue tarp cling to a cyclone fence.

Crossing over the main street,
A few cars move through past empty storefronts.
The Mexican restaurant is open,
Customers sit at their tables, lost in their phones.

After a few more blocks,
A dual cab Ford truck screams
Up behind me and passes.
Two teenage white kids in the front smoke
And nod their heads to the bass crunch
Of some guy singing about life in Newark or LA.

With a quarter mile to the next intersection,
The driver hits the accelerator,
Smoke and noise blasting the night.
Oversize chrome bull gonads swing from the trailer hitch,
As if the truck itself is searching for the crystal heifer.

As the light leans from yellow to red
The truck slows and turns right into a neighborhood
Of low-slung houses and thirsty cottonwoods.
And with that, the rumble fades to a harmless murmur.

Continuing through and out of town,
I rise up the other side of that slow valley
And sight the necklace again in the rearview mirror,
The fallen stars pulsing in the mix of dust, heat and cool air
Coming down from higher up on the shoulder of the earth
And I think about those two boys
Probably now parked in some driveway,
Talking quietly in the TV glow
Coming through the front window.

04 I CAN'T EXPLAIN

The color purple
Not red not blue
The space between a kiss
The way I feel for you

A string of stars
Ties that bind
You and me
Across all the time
The touch of your voice
The shape of your name
So many things
I can't explain

The common thread
Wrapped around
It feels like music
Like heaven sounds

Galaxies spin
We'll meet again
Under the mirrored ball
That's the mystery of it all

DARDEN SMITH / GRACE PETTIS
DARDEN SMITH MUSIC (ASCAP) / SOONBLOOMED SONGS (ASCAP)

CANE

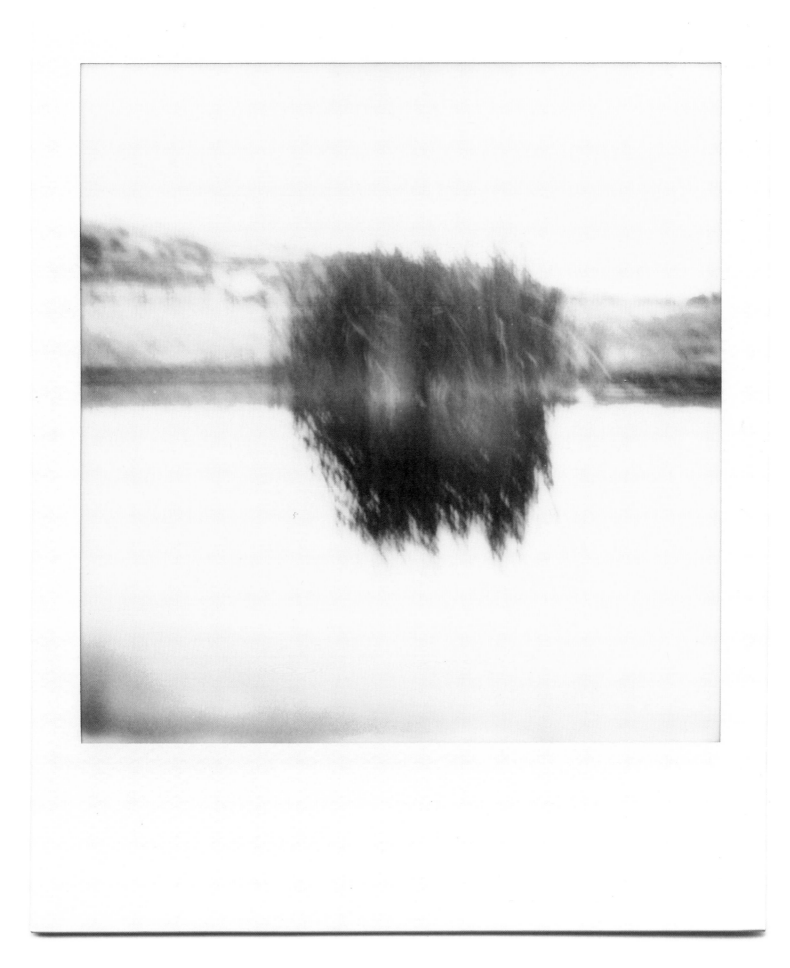

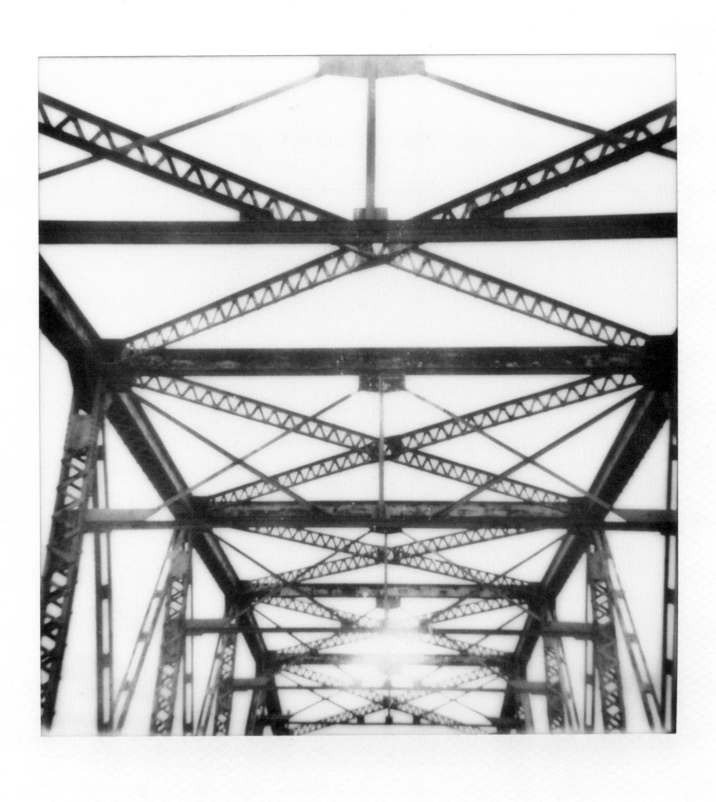

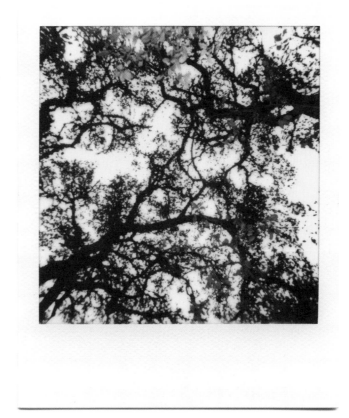

OAK

CROSSING

SANDERSON CANYON

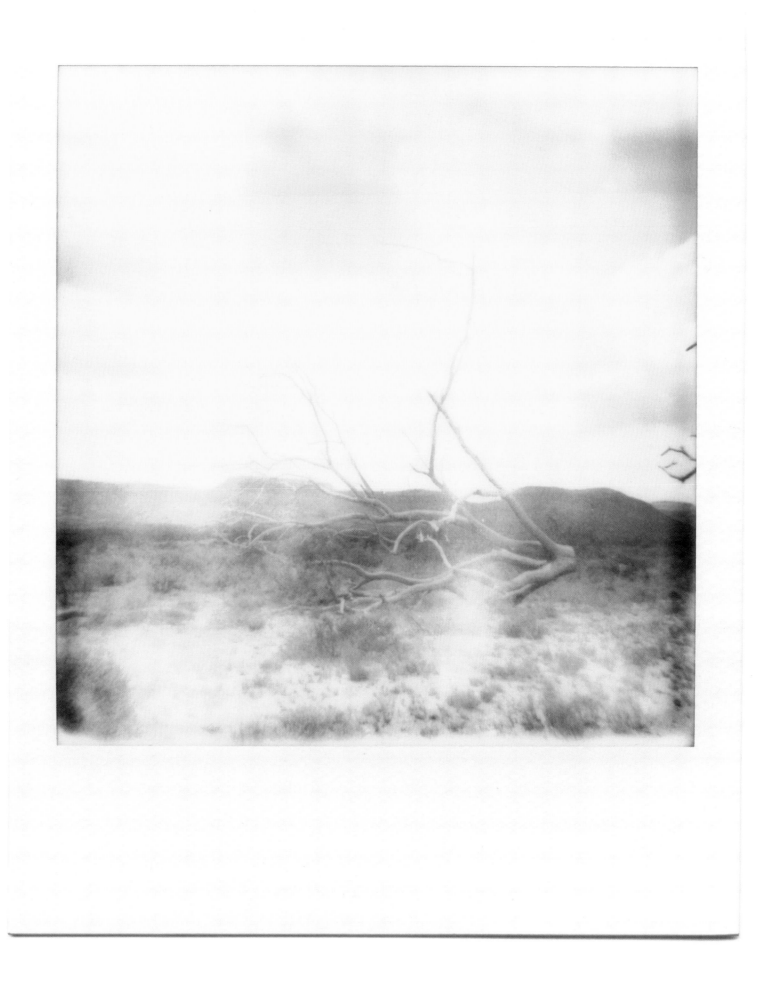

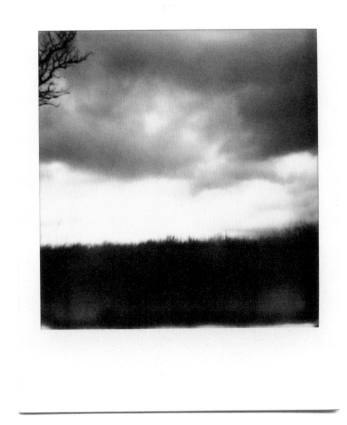

JANUARY SKY

RAIN

The smell of cloud
Catches the heart of the most jaded
For even they know the promise
Of what may follow.

The wind, that outrider of a frustrated god,
Scrapes across the plains,
Lifting hope and earth
Only to drop both in some unmarked place
Without so much as a kiss goodbye.

A slow rain is best
But the leavings rarely satisfy
Because in this country
There is never enough.

Torrents are longed for and dreaded in equal measure.
Their quantity dreamed of,
Speed and destruction often remembered too late
As the flood runs wild over road and arroyo,
Trapping the innocent and slow
In a death spin of leavings and mud.

I pull my cap low
To stand amongst the great washing,
Breathing in this gift of water
Rolling under collar
And between shoulder blades,
Thinking of the hidden seed
Buried years ago
In some other storm.

Knowing I'll never see its bloom,
I'm reminded that rarely
Do we witness
The becoming of our days.

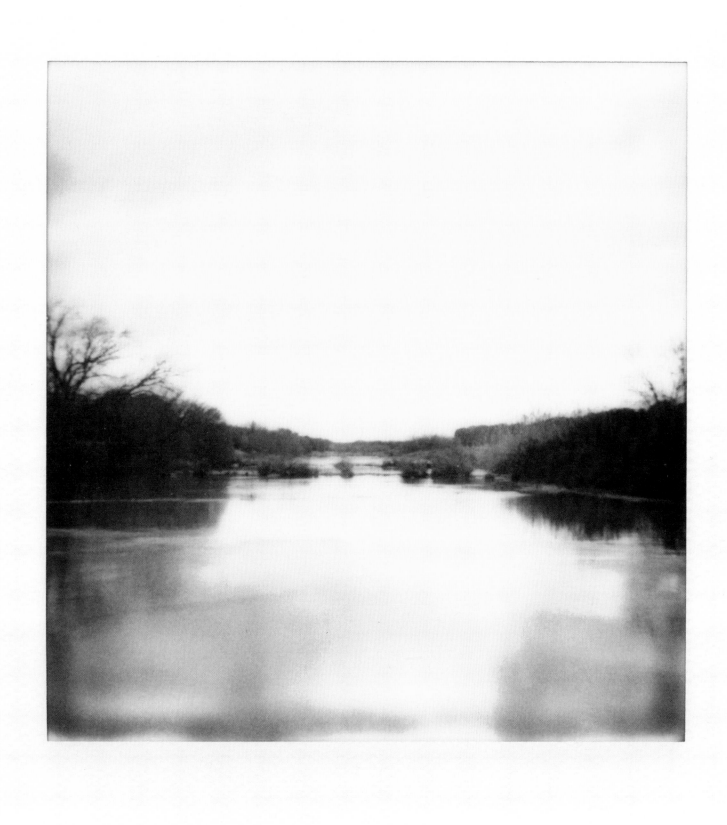

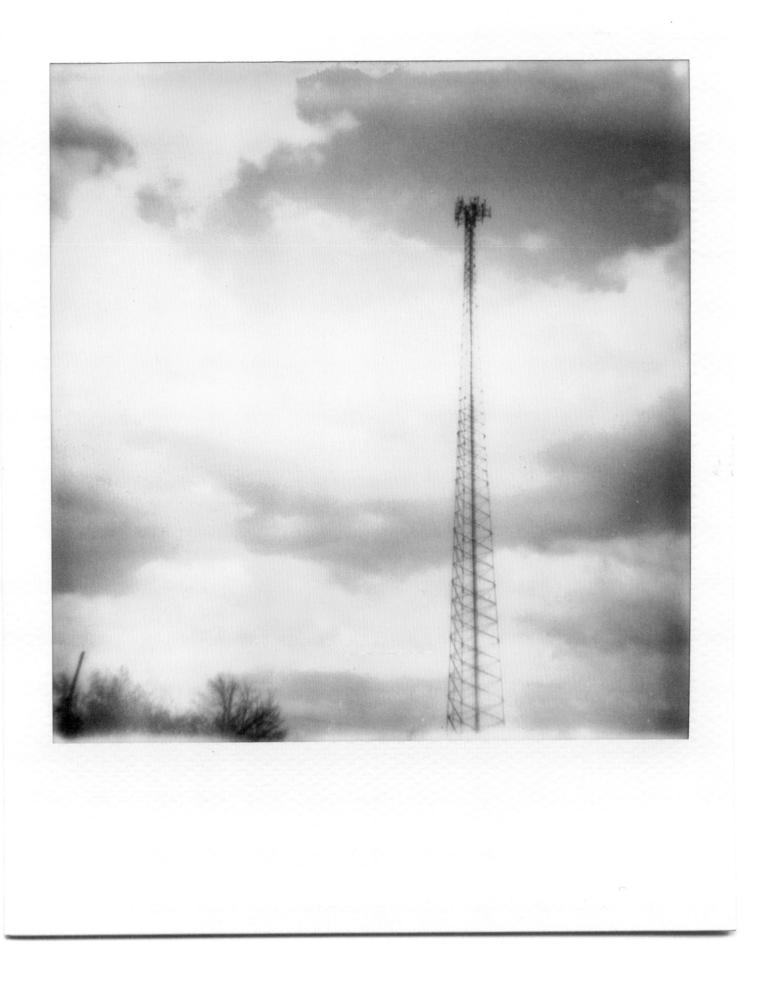

TOWER

THE COM
AND THE TRAIN

I drive out beyond the edge of the light to see the comet. Pulling off the road, I park between the railroad track and a ranch gate. Only the occasional car breaks the deepening blue, the rise and fall of headlights fanning out and across the land in search of something to hold onto. There is none. Silence and falling night hold off all comers.

After the long dusk, stars and satellites appear in rapid fire, filling the space where before the dimming day was enough. The Milky Way rolls above me. Somewhere away a dog barks at some unknown threat. Or maybe it's in reverence. One never knows with dogs. Birds quiet, at least those of the day. In their place the nocturnal wings hunt for invisible food. A coyote howls.

This nightly turning. It cares not a flit for me. Were I not here, or if I am here forever, it would be happening regardless. It's happening still.

Finally, just below the Great Dipper, the faint smudge of light that is the comet begins to show, visible only if I glance to its left or right, which seems an honorable and fair agreement— like a beautiful woman whose radiance is only truly known once you look away.

I wonder at what ferocious maelstrom is needed to create a disturbance visible light-years away. Fire, rock, ice, chemicals, all feeding incessantly on each other, pulled forward by a force even older and more powerful than itself, so frightful it can send this mass careening through heaven, yet tender enough to make it appear still and quiet, a thing of great beauty, a stillness instead of a living, dying, ferocious thing.

And at that moment, I hear a train whistle, and turning to look behind me see a far-off light just beginning to glow on the eastern horizon, still a mile or more away. Moments later the beacon rises above the wrinkle in the earth and sweeps across the scrub. Soon I feel the ground pulse beneath me. The cold metal rails begin to pop and converse like mice running for cover at the sound of footfall. And before it seems possible, the train is upon me, crashing through the night, pushing aside all emptiness that might stand there. With its roar and quake, motion and blurring of light, it dominates my senses. The train is the only thing here now. The birds, the land, even the stars and comet are rendered mere fragments of something that once existed, swept aside by the brashness of this iron bully.

I move to stand as close as I can to the tracks. I feel the wind from the beast's passing, the violent shaking underneath and in my bones, see the rails rise and fall with the weight of the wheels, and the sound overwhelms me in its complete unnaturalness, all steel and brute force volume against gravity's steady pull. After a few minutes my need for refuge takes charge and I have to step back. A moving train is a furious thing.

And then, just as quickly as it arrives, it's gone. The descending rumble of its exit leaves a vacuum to be filled by all that was there before. The nighthawks and bats, the starry pieces of light all take their place once more among the dark. Even the wind dares to raise its voice, bringing a welcome coolness from some distant elevation, like a late arriving guest at a flagging party.

And the comet.

During all the train-induced chaos it doesn't even move, doesn't seem to notice. Nor do the Milky Way, Orion, or the nighthawks for that matter. Because to them the chaos of the train is a tiny thing: a nothing. It happened, and now it is gone. The night still turns. The great galaxy knifes its way through the sky. And with a finger snap in the passing of time, I myself will be gone, driving eastward again into the morning light of our own little star.

We make such a big deal of the present. Lost in our assumptions and wrongheaded constructs that what is occupying our vision is a static, forever thing, when really there is always a grander motion. We're surrounded by stars, a comet hangs in the sky, and we instead let ourselves be overwhelmed by the train.

The chaos of any moment tires of itself eventually.
The train moves on to some other crossing. And then another.
Stillness is always at the ready, waiting for our attention.

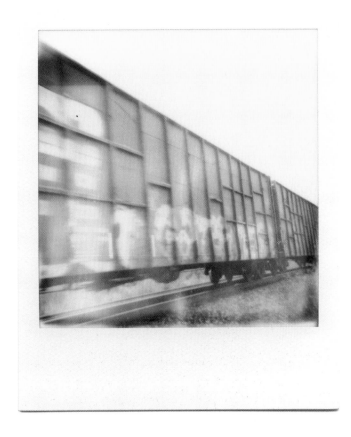

FREIGHT

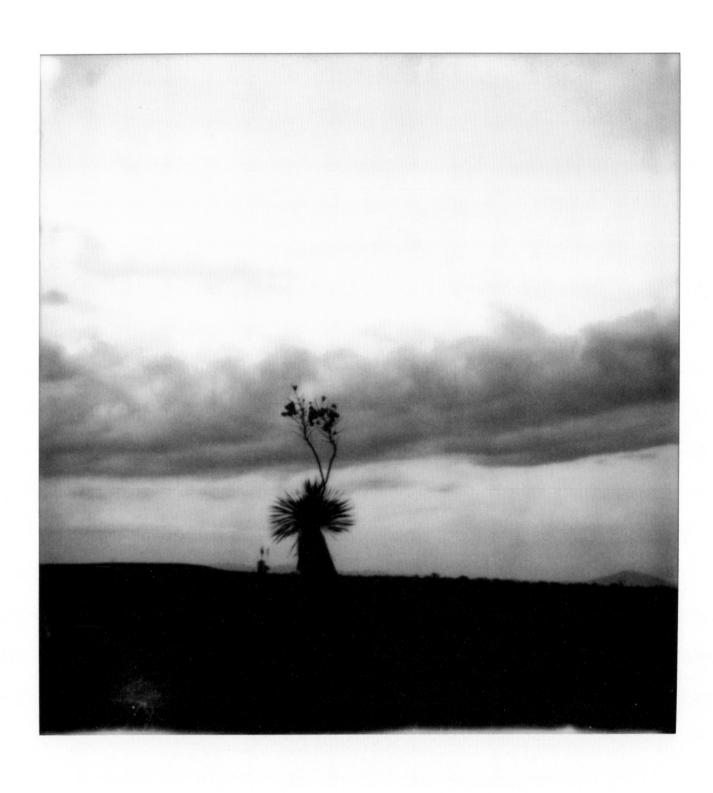

05 NOT TOMORROW YET

I feel a change in the weather
I feel a change in the heart
And I wonder if it's all over
Yes, I wonder how to make a new start

I'm going down, going down, going down, down into the valley
I'm gonna rise, gonna rise through the pain I can't forget
Come a day, come a day, be a day I put the struggle behind me
It's alright, it's alright, it's alright, it's only midnight
Not tomorrow yet

Must be a reason for the high cost of living
Must be a reason for the price you pay
Pocket full of money won't get you into heaven
But what a way to go, that's what the rich folks say

I'm going down, going down, going down, down into the valley
I'm gonna rise, gonna rise through the pain I can't forget
Come a day, come a day, come a day I put the struggle behind me
It's alright, it's alright, it's alright, it's only midnight
Not tomorrow yet

I'm going down, going down, going down, down into the valley
I'm gonna rise, gonna rise through the pain I can't forget
Come a day, come a day, be a day I put the struggle behind me
It's alright, it's alright, it's alright, it's alright
It's alright, it's alright, it's alright, it's alright
It's alright, it's alright, it's alright, it's only midnight
Not tomorrow yet

DARDEN SMITH / JAMES HOUSE
DARDEN SMITH MUSIC (ASCAP) / JAMES IN THE HOUSE MUSIC (BMI), ADMIN BY WIXEN

VIEJA

It's always here. Though it hides, rests at times, pauses like a wild animal whose attention is temporarily distracted, the wind always returns. And with so little in its way, it has time and miles to build, to gather beauty, anger and form, carrying this great and steady force that is the unspoken envy of many an army, countless lovers, of love itself.

The brittle earth rises with it, lighting from its resting place in swirling funnels given to huge browning clouds, blocking light, masking both road and horizon. The dust lifts into the near sky, crossing plains, slipping around windows and sleeping eyelids, coloring all in its scratchy haze. As if in bitter revenge, it brings the distant fields to this place and carries what is here onward in a constant rearranging of dreams for those who call this home.

Against this march, train cars and trucks weave like evening drunks. Drivers brace the wheel. Plastic bags cling to barbed wire fences, keeping ragged score in the rise and fall of gusts. We are all buffeted in this together.

Yet the ocotillo, agave and grass give no ground. Trees hover low, only venturing closer to the sky if in the lee of rock wall or roofline. Maybe they have the added strength of a dry creek bed, standing in confidence that since there was water here once, there will surely be again.

Everything both alive and inanimate here accepts the wind in a stern holding stance. For to give up, to let go of the ground is to lose any sense of permanence, to be tossed forgotten amongst roadside scrub, lodged against fence line or foundation until time or the lack of water finishes off what little remains.

Only the sky, with its clouds, stars, rain, funnels of swirling earth, crows, hawks and countless other birds, is treated with any respect. Because from the beginning it and all it holds never expected to stay here. There is no grasping for root to give meaning. Lasting is not a thought. Moving through is the only truth.

If only I could be more like this. Then so much of my turning away from the elements, shielding eyes, ears and mouth against the grit of the dust, chasing after lost scraps of paper and receipts, the record of my movement through this world, all these reminders that I am here, that I once was and that some part of me lasts, would all be forgotten.

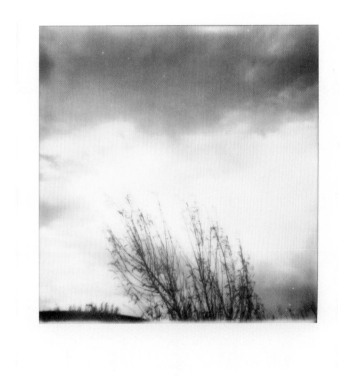

DRY MARSH

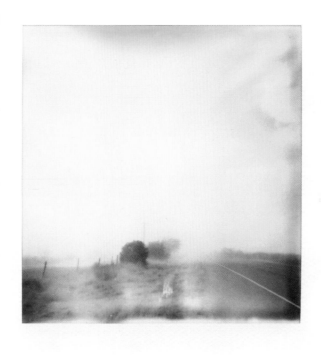

DUST STORM

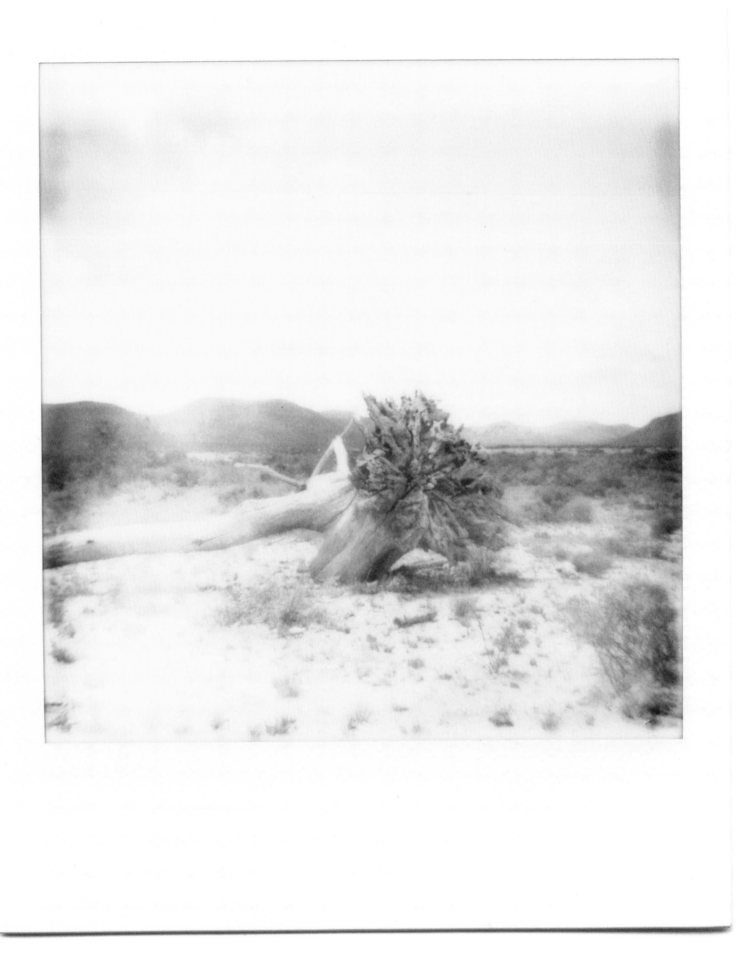

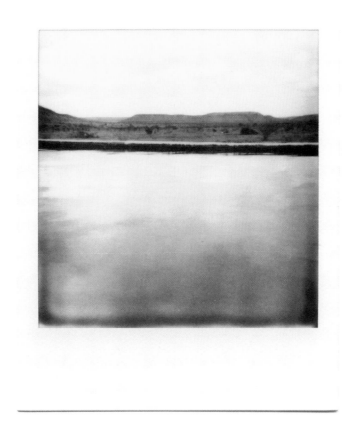

TANK #2

ROOTS

06 TURN THE OTHER CHEEK

People hurting people with their angry words
I wonder have they ever, ever heard
About loving another as you love yourself
And keep on reaching down to help the weak
Show a little mercy and forgiveness
In what you do and what you say
And turn the other cheek
Oh, turn the other cheek

'Cause it don't make you taller to bring somebody down
Make me think of Jesus with his thorny crown
Talking about loving one another as you love yourself
Just keep on reaching down to help the meek
Show a little mercy and forgiveness
In what you do and what you say
And turn the other cheek

I sing this for the children, the children's children too
Trying to get the message, I'm trying to get to you
Come on love one another as you love yourself
Just keep on reaching down to lift up the weak
Show a little mercy and forgiveness
In what you do and what you say
Oh, love one another as you love yourself
Just keep on reaching down to help the meek
And just show a little mercy and forgiveness
In what you do and what you say
And turn the other cheek
Oh, turn the other cheek
Careful what you speak
And turn the other cheek

DARDEN SMITH
DARDEN SMITH MUSIC (ASCAP)

TIRES #2

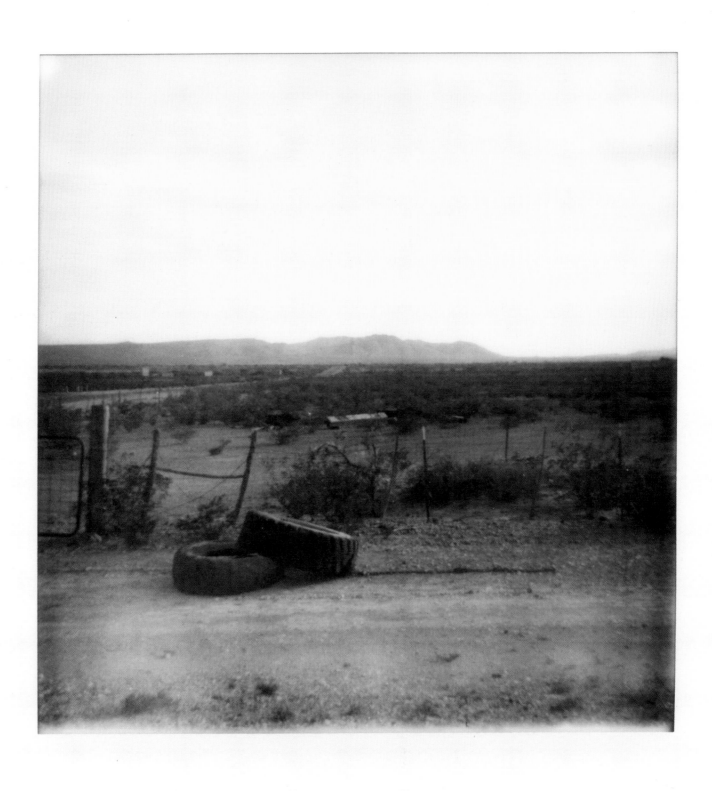

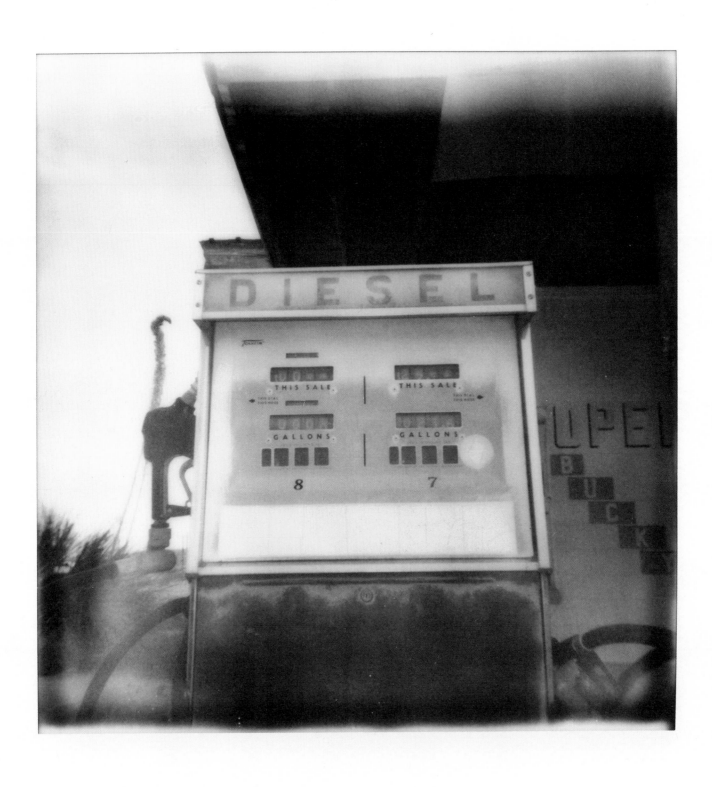

DIESEL

THE RECONCILI

The eyes are the first to struggle.

What appears fixed, photographic, isn't.

Grass, agave, far-off stands of mesquite and cottonwood, dust and cloud, light and shadow, all sift into a slow-motion reckoning of vision.

The hearing settles to the heartbeat's thrum.

With time it fades as well leaving only a black void, and I empty myself into its hollow.

I snap these sonic distances with words, a footfall on broken twigs or a half-remembered song if only to establish some small place for myself.

In this I am forced to confront my own true presence, reconciling that I am just one more indefinite upright thing moving across these stones and between gusts that surely will rise again in the eventual erasing of my name.

And through this silence, across these miles, I search for the stillness I already hold but can't quite name, that surrounds, lifts and carries me like an errant child found far adrift, home.

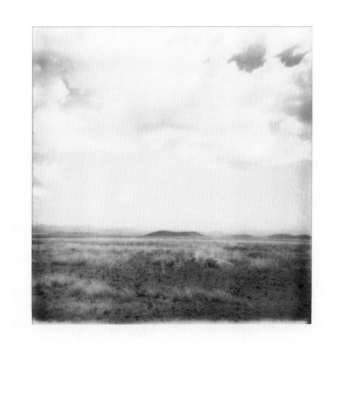

BLACK HILLS

07 PERFECT FOR A LITTLE WHILE

It was perfect for a little while
Everything a love should be
Easy days and endless nights
Making plans and dreaming dreams

Well I keep holding on even though it's wrong
'Cause your memory makes me smile
Like that summer moon
It always leaves too soon
Oh but it's perfect for a little while

I remember when, when I said to you
It seems like I've been here before
And somehow I knew, too good to be true
Come a day you won't love me anymore

I keep holding on to your favorite song
It gets me through the many miles
Singing harmony like it was you and me
Oh, it was perfect for a little while

I can hear it raining
Under cover of that old tin roof
When you still needed me
And the storm was passing through

And I keep holding on even though you're gone
Your memory, it makes me smile
Like that summer moon
It always leaves too soon
Oh, but it's perfect for a little while

Like that summer moon
It always leaves too soon
Oh, but it's perfect for a little while

DARDEN SMITH / JAMES HOUSE
DARDEN SMITH MUSIC (ASCAP) / JAMES IN THE HOUSE MUSIC (BMI), ADMIN BY WIXEN

PONY

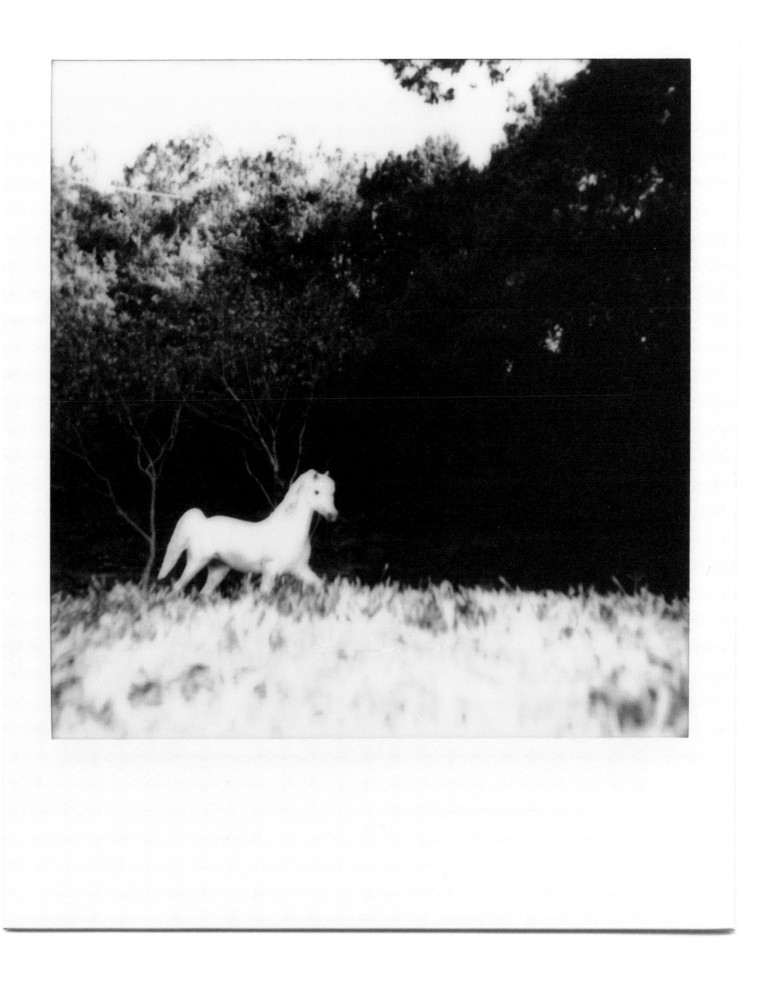

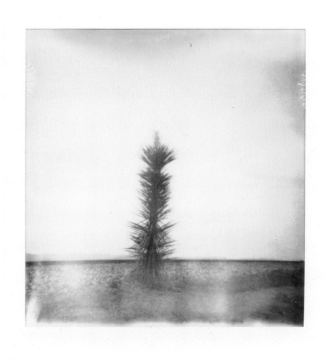

UPRIGHT

DISTANCE

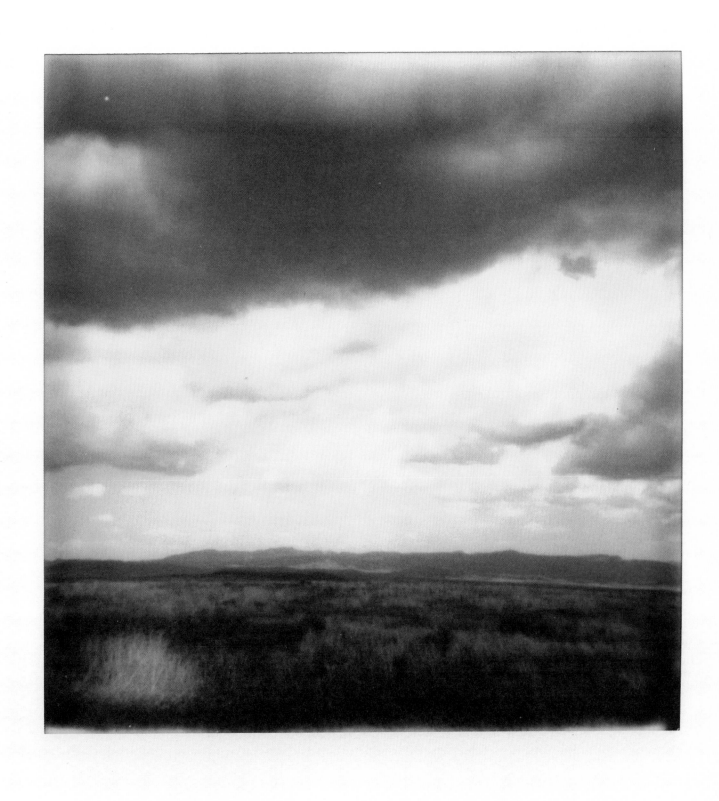

The land slouches off towards a distant angle
Five miles away. Maybe ten.
It's hard to know for sure in this light.

Colors slip green to grey
To mud-brown caramel
As distinct cactus and greasewood,
Raw earth and grass give way to a
Deceiving oneness.

This land is one thing to look at
But another entirely to walk across.
On foot it would take the day and maybe half the night
To reach where the table shifts to meet the mountains
Rising up from the south.

How many have passed over these stones,
Sensing in the smudge of shadowed grama
And thin line of trees the hidden spring,

Its damp fortune sliding on an east–southeast grade
To meet the unseen river,
But lacking rig, gasoline and drill bits
To bore through and fill their wounded cup
They keep moving
Carrying only desire and a stumbling sense
Of direction.

Yet even as stakes and dry bones vanish
Beneath layers of dust, time
And the crow's brittle song,
Always, always within the earth's belly
Will that cold and steadfast grace
Seep stone to sand, gravel to ancient shell
Across and around layers of limestone floors,
Crusted volcano, and abandoned civilizations,

Picking up and putting aside memory, words,
All that is, and all that can never be, seen or known
In our journey to find the other sea, cloud and storm

To fly within and fall once more
In the ageless circle of mercy.

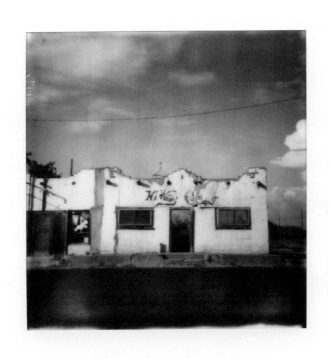

OPEN DOOR

HORSES

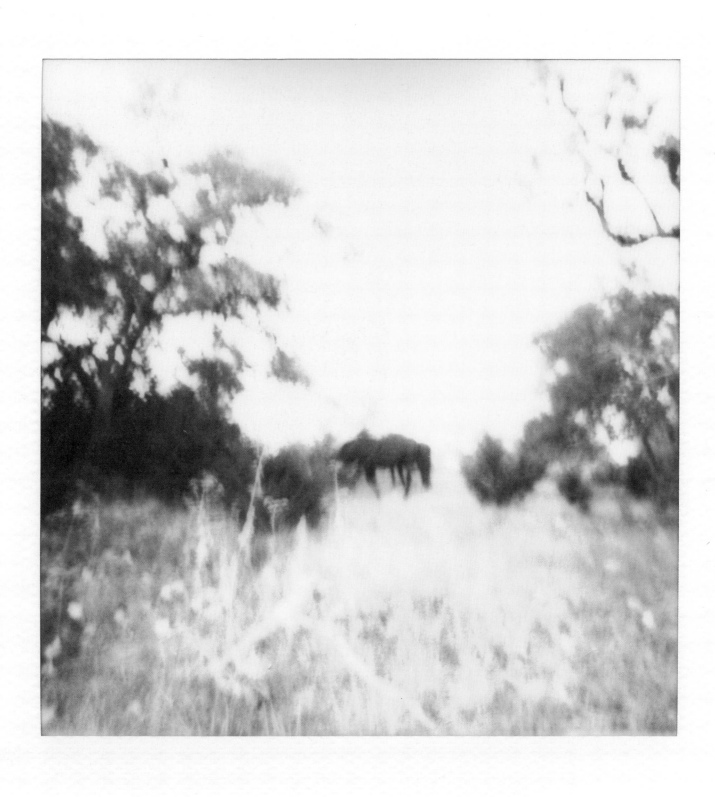

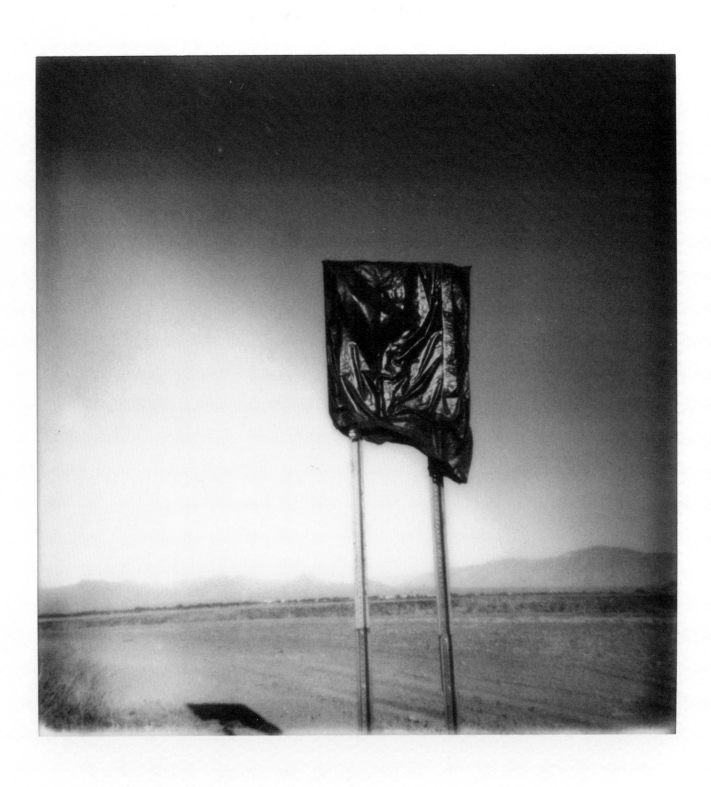

SECRET SIGN

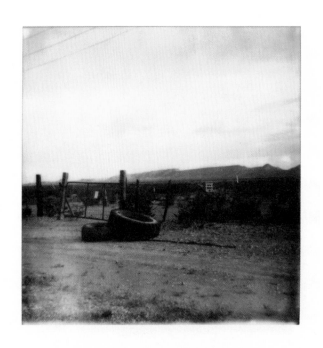

DRAGGING TIRES

ORDER CROSSING

It takes either a desperate or a crazy soul to walk across the border and through this country. Water and shelter are rare. Just the plants and hard ground are enough to stop you. Everything about this landscape is on the offense. A man, woman or child, together, alone, become prey.

Anyone who makes it should get a medal.
Instead, we threaten them.

What would it take, how dismal must it be, to leave your home, family, connections, and go through all that is involved just to reach the river, much less cross the desert on this side? Aren't we told to love the poor, the outsider? Instead we round them up like cattle.

Where's the love in that?

A clean grade has been scraped into the dirt along the road. Bladed smooth and dragged with tires, the surface lies waiting for a stranger's footprint. I see the border patrol agents in their off-road vehicles driving up and down the paths at dusk like hunters setting traps. These silent walls. What a deadly game.

I move down this road, knowing that somewhere across the flat between here and the Sierra Vieja, a pair of eyes, maybe dozens, watch my headlights, catching the glint of reflection possibly, marking the place, the distance to this silent barrier, one among many put here to block the way to the promise.

08 THE HIGH ROAD

If all the king's horses, all the king's men
Found you at the bottom, brought you back again
No matter how far you run, how fast you've sinned
I'd forgive what you done, where you've been

If you make it back to me
Well there ain't no reason left to leave
When what you want, what you need
Is the high road that will bring you back to me

Time to straighten up now, time to fly right
Here's to hoping that the dark won't win the night
The ghost won't follow in the light of day
The love that we'll swallow will take the pain away

DARDEN SMITH / ROB BAIRD
DARDEN SMITH MUSIC (ASCAP) / BOOTS BAIRD MUSIC (BMI)

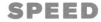

SPEED

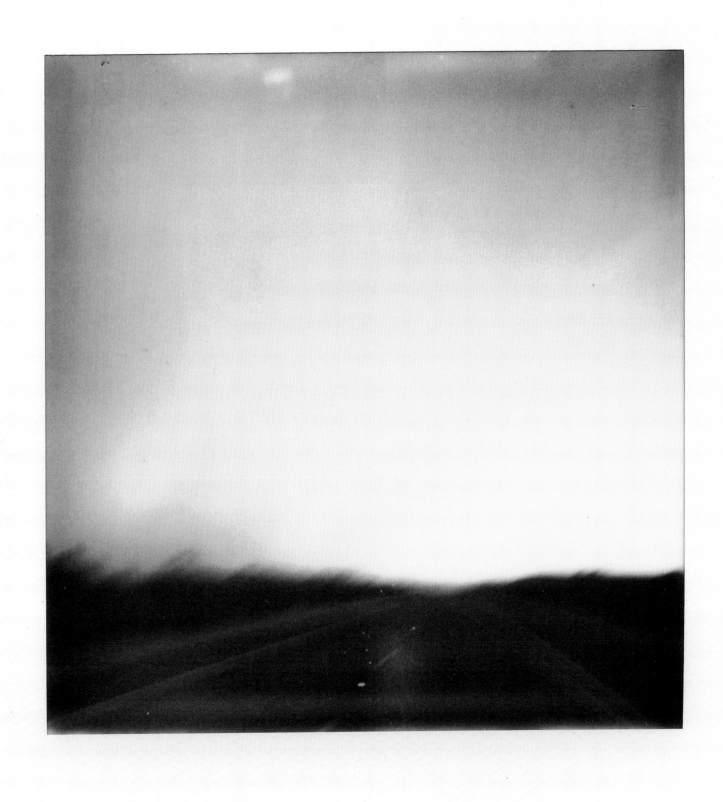

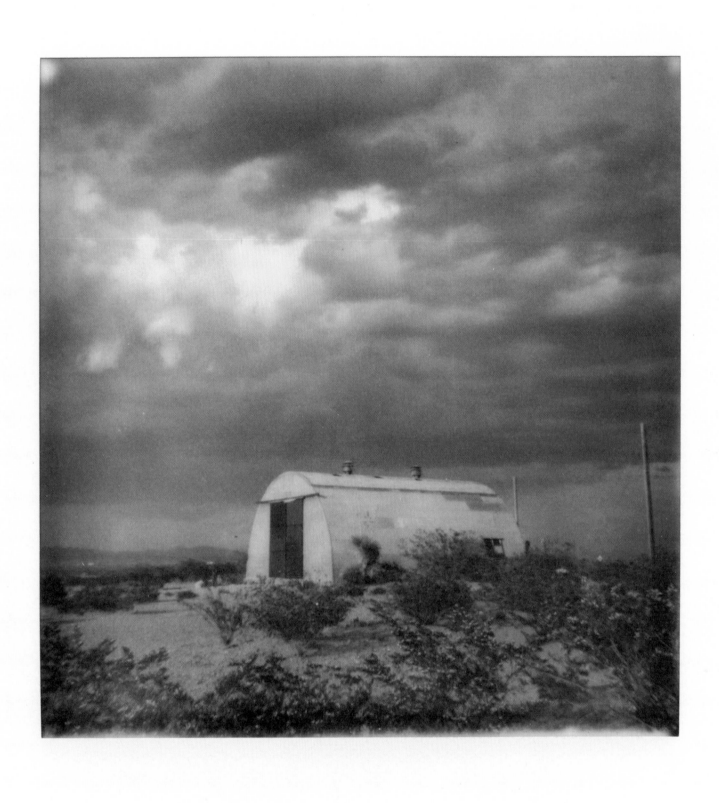

COTTON

QUONSET

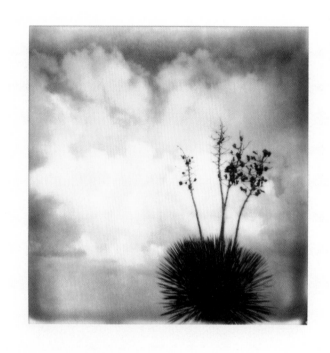

YUCCA

THE BOWL OF BLUE SKY

Walking under the bowl of blue sky
Talking to the shadows and the wind
I taste you now in every drop of water
Your name upon my lips, upon my skin

Rivers, blacktop roads, the darkest mountains
Fear another border I must cross
No sun can ever burn away my hunger
To make up all the time that we have lost

On that day before there was this walking
Before we named the tears that wouldn't dry
Across the cold, the breaking dawn, the morning
I held you and together we did fly

Now I drift unseen among the hours
Through this land of breaking backs and bones
Slanting in some northerly direction
Still upright among the casted stones

Until that day I turn and travel homeward
To hold you close and drink your diamond sigh
I touch your name and feel you here beside me
Walking under the bowl of blue sky

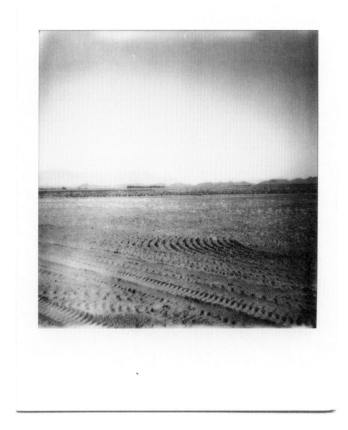

FIELD

BROKEN

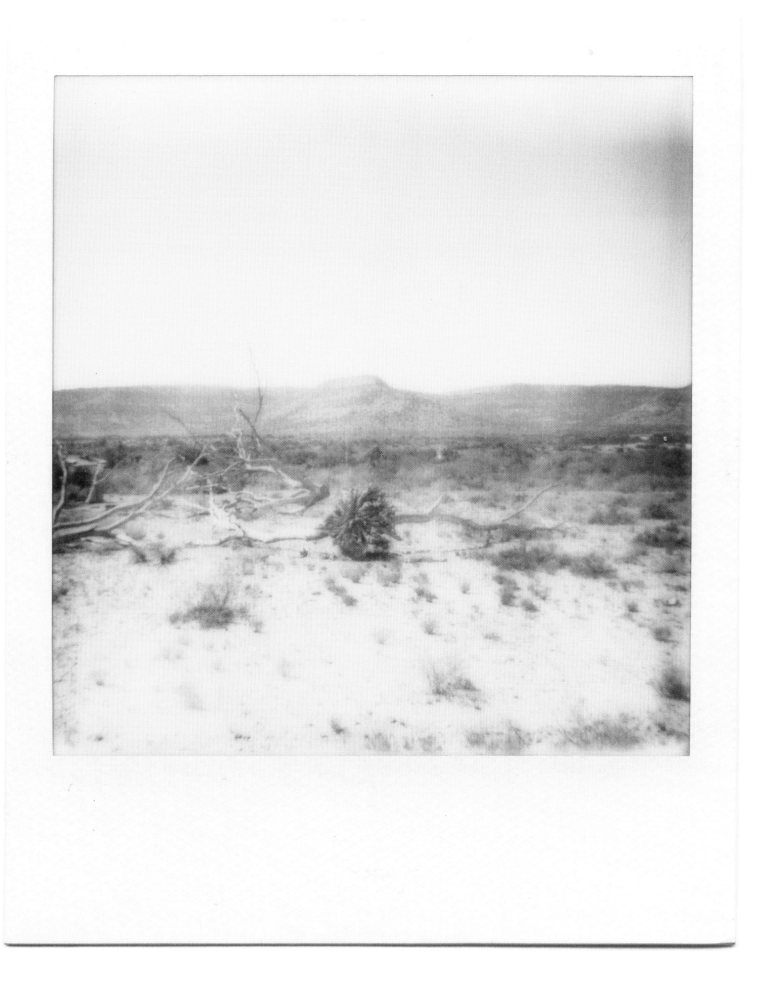

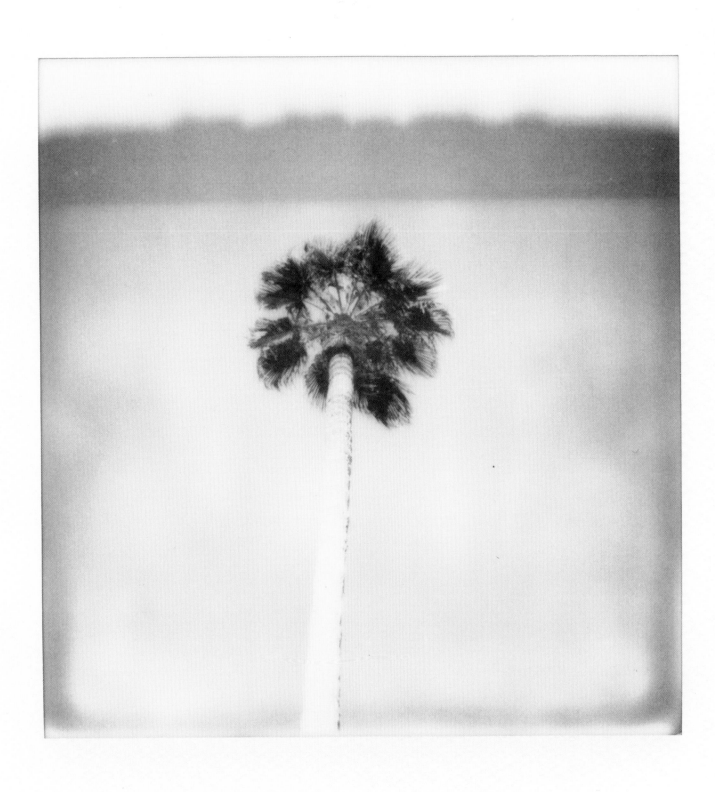

09 LOS ANGELES

I remember the way it felt that day
You lay next to me in Los Angeles
The sun was just setting, the moon wasn't up
But the planets were spinning all around Los Angeles
Los Angeles

Time can never replace
Can never erase
Los Angeles

From the Valley to the sea
Up and down all the boulevards
You're nowhere to be seen

But I still feel the way I did that day
The planets were spinning all around Los Angeles
Los Angeles

Time can never replace
Can never erase
Los Angeles

DARDEN SMITH
DARDEN SMITH MUSIC (ASCAP)

SIERRA BLANCA

The road rises steady from the Pecos
Past the truck stop visions of Fort Stockton,
The northern reaches of the Davis Mountains
And the gatherings of Van Horn,
Through the little town of Sierra Blanca,
Westward to the pass just beyond.

From there I can see the earth in its
Slow, leftward slant towards the Rio Grande
And the mountains beyond.
As smoke and people come north and east
From the factories and lights of Juárez and El Paso,
A blue haze drifts south
To the unseen border,

And I sense the great exhalation that often comes
When moving through a desert pass.
It's the promise of the mirage,
The unobtainable but dreamed of welcome.

But there is no resolution here.
No one single light calls me forward.

I can only hold
What I gather within myself
And apply to the accelerator
As the raised volume of an AM station
From somewhere south
Speaks in a language I don't understand
But believe is put on the tongue to calm my fears,
Bellow my hope
And get me through
This oncoming
Night.

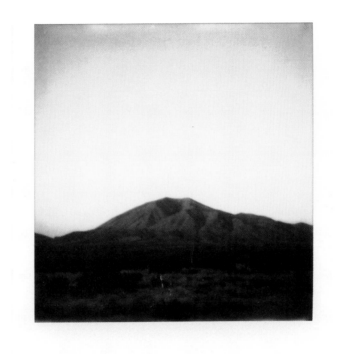

OBSCURA

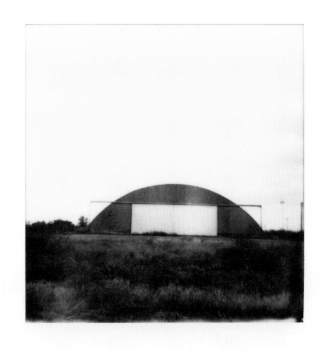

STORAGE

10 I DON'T WANT TO DREAM ANYMORE

I don't want to dream anymore
I don't want to dream anymore
They just aren't the same as before
I don't want to dream anymore

I don't want them not to come true
I don't want them not to come true
Especially when I'm dreaming 'bout you
I don't want them not to come true

I say oh, the sound of your key in the door
Oh, just to hear your feet on the floor
I don't want to dream anymore

Sometimes when I'm lying awake
Sometimes when I'm lying awake
I can feel my own heart break
Sometimes when I'm lying awake

I say oh, the sound of your key in the door
I say oh, just to hear your feet on the floor
I don't want to dream anymore
I don't want to dream anymore

DARDEN SMITH / JAMIE LIN WILSON
DARDEN SMITH MUSIC (ASCAP) / JLGW SONGS (BMI)

CLOUDBURST

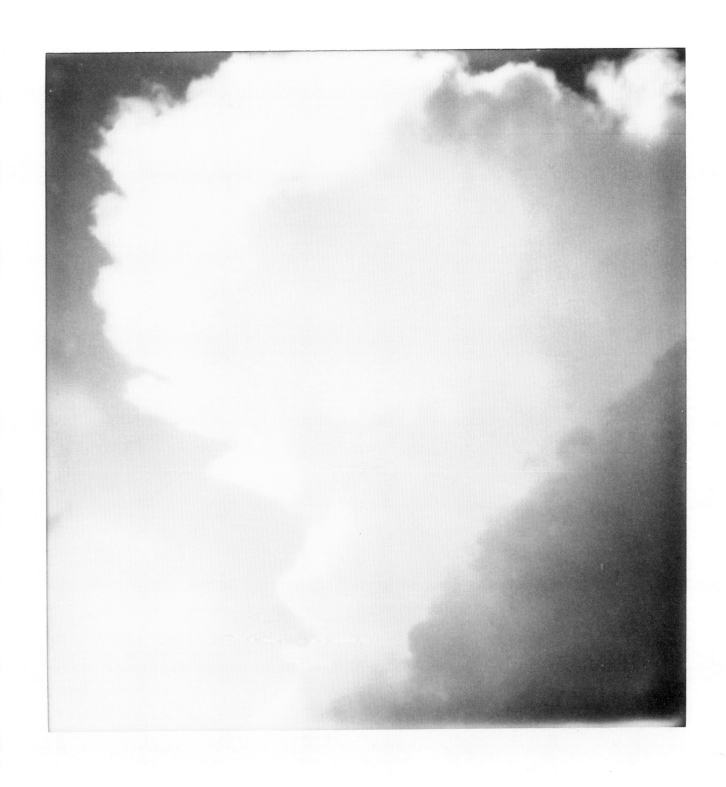

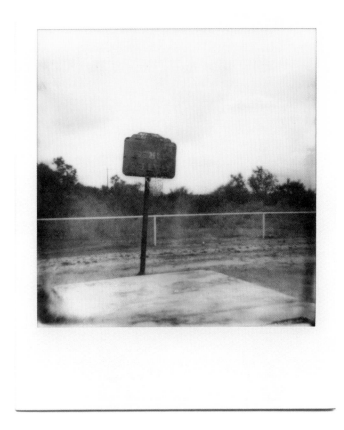

PARK

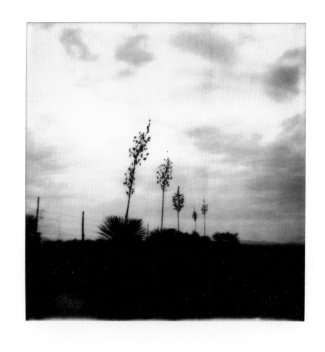

YUCCA #2

LOBO

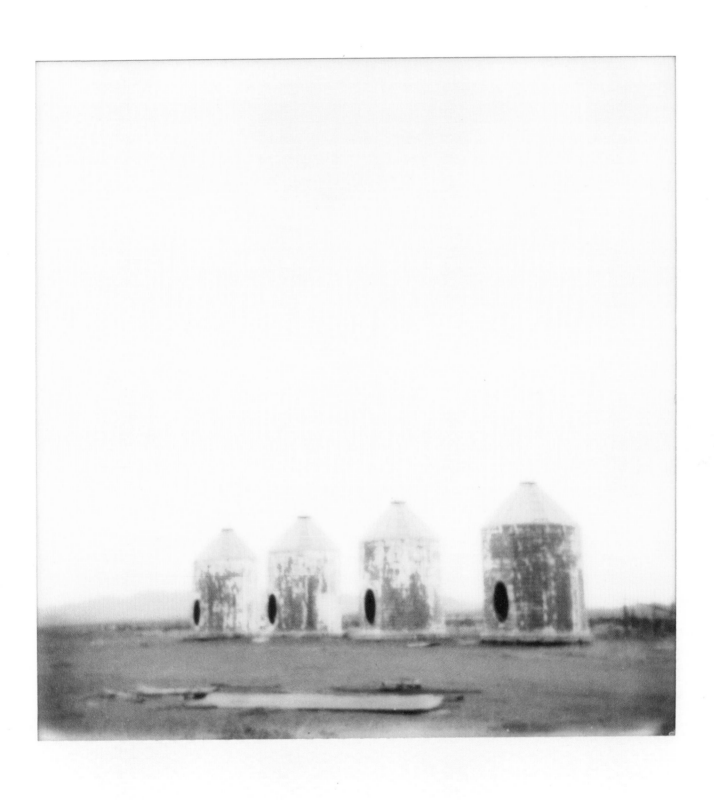

CONTINENTAL BREAK

The break in the land sits like two lovers back-to-back.

One faces east glancing north.
The other, with shielded eyes, looks west
And hesitantly south.

The first imagines that if wanted, with time,
It would be possible to retreat,
Go back across this rock punish
To the welcoming shade of maple, oak, slow moving rivers,
Humidity and the promise of tall cities.

For the other, only the Pacific brings rest.
And between now and the advancing night lay
Miles of unforgiveness and silent movement
Through empty light
Scattered across this rib of leathered earth
Broken only by the dark and fading oases
Green with water stolen from a thousand miles away.

In my mind, this is the true continental divide.
The difference cuts not only down into the earth's crust
But slices skyward, separating light, clouds
And the gravitation of dreams.

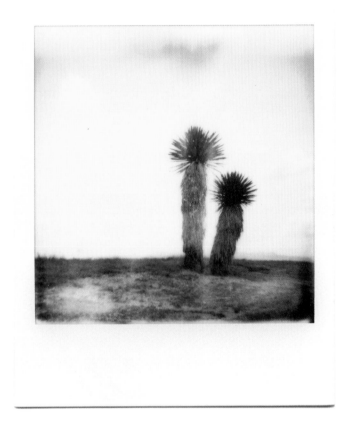

SENTINELS

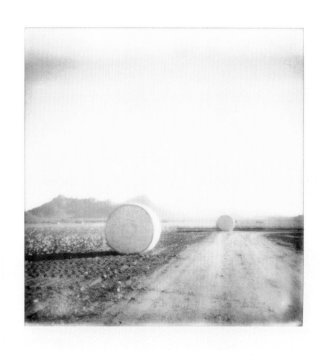

COTTON #2

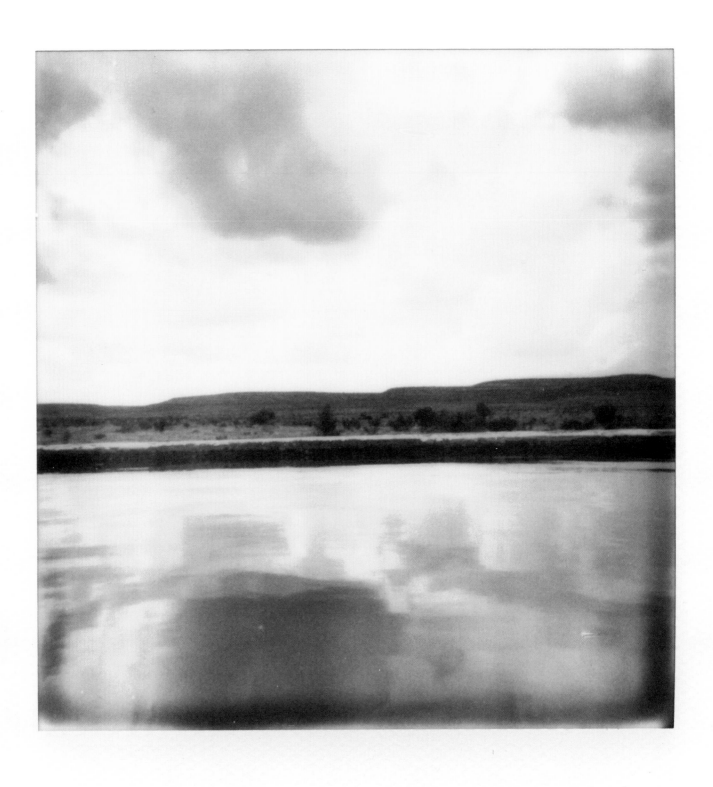

TANK #3

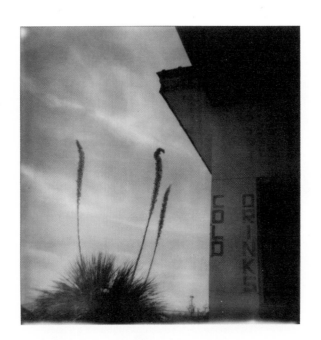

COLD DRINKS

Juárez stretches across the bed
Between the mountains
Just daring you to come to her,

Reaching down
Down into whispered hopes,
Through dust, heat and faded colors
Mixing with trace danger.

Driving west on I-10 I see the city arcing its back to the rise.
Smoke plumes stand amongst the maquiladora's haze.
Closer into El Paso, the city grows more dense
Until finally the interstate runs right along the river
And I see through windows into houses
Creeping up hillsides threatening
To laugh and tumble right back down
And over the border.

With just a thin line of water between them,
The two are joined forever.
Which is the dark twin I can't work out
But still can't look away.

Juárez is the girl your instinct tells you to walk, no, run from
But whose memory wakes you in the night,
Sweating, aroused,
Listening, hoping for her
Footsteps.

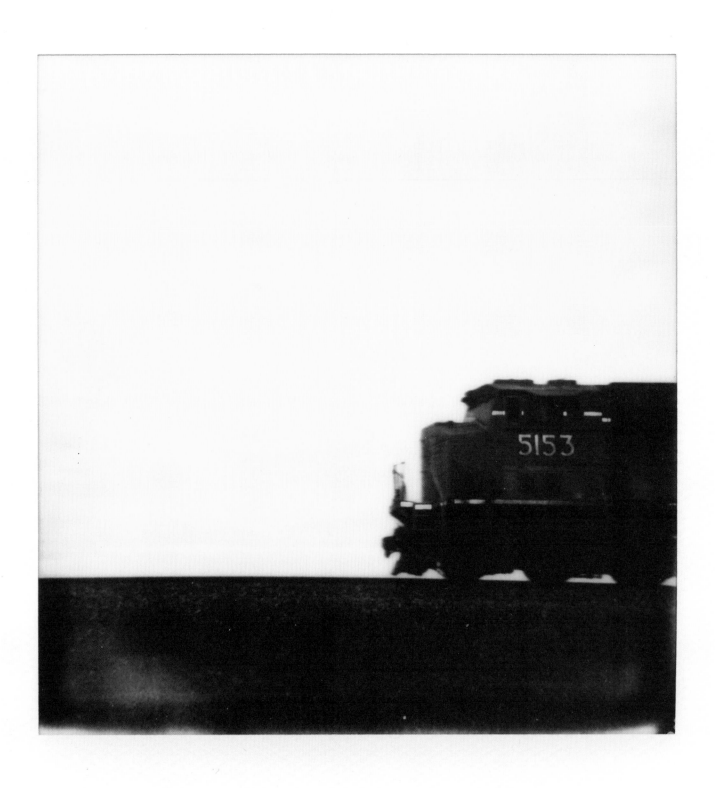

5153

11 HUMMINGBIRD

Hummingbird in the dark with your magic wings
Guided by a distant star to those pretty things
I know how it feels to long for something sweet
Hummingbird in the dark sweep me off my feet

Crooked road brought me here so very far from home
Desert rose, bitter tears, left me all alone
I know you might find her in some morning light
But 'til then hummingbird stay with me tonight
Stay with me tonight

I know what it means to long for something sweet
Hummingbird in the dark come sweep me off my feet
Come sweep me off, sweep me off my feet

DARDEN SMITH
DARDEN SMITH MUSIC (ASCAP)

SUNFLOWERS

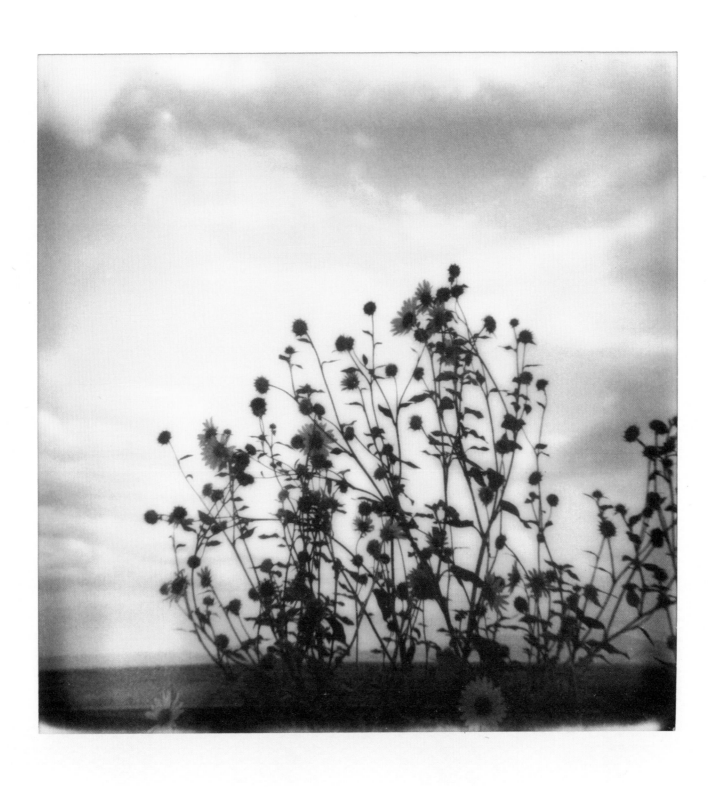

CREDITS

PRODUCED BY
Michael Ramos, Stewart Lerman and Darden Smith

RECORDED AT
Sonic Ranch, Firefly Studios and Brown Recluse Studio

MIXED BY Stewart Lerman at Hobo Sound, Weehawken, NJ

ENGINEERED BY
Mario Ramirez, Dan Flynn and Michael Ramos;
Assisted by Jon Clover-Brown (Firefly Studios)

STRINGS RECORDED AT Hobo Sound

MASTERED BY Gavin Lurssen at Lurssen Mastering

DESIGN BY Stu Taylor and DJ Stout at Pentagram Austin

PHOTOGRAPHY BY Darden Smith

AUTHOR PHOTO BY Bill Albrecht

MILES BETWEEN
Piano, Acoustic Guitar, Percussion, Vocals **DS**
Bass **GLEN FUKUNAGA**
Drums **RAMY ANTOUN**
Acoustic and Electric Guitar **CHARLIE SEXTON**
Pedal Steel **RICKY RAY JACKSON**
Vocals **JAMES HOUSE**
Loops **MARIO RAMIREZ**

RUNNING OUT OF TIME
Piano, Acoustic Guitar, Vocals **DS**
Bass **GLEN FUKUNAGA**
Drums **RAMY ANTOUN**
Electric Guitar **CHARLIE SEXTON**
Strings **DAVID MANSFIELD**
Vocals **JAMES HOUSE**

WESTERN SKIES
Acoustic Guitar, Keyboards, Vocals **DS**
Bass **GLEN FUKUNAGA**
Drums **RAMY ANTOUN**
Electric Guitar **CHARLIE SEXTON**
Keyboards **MICHAEL RAMOS**

I CAN'T EXPLAIN
Acoustic Guitar, Vocals **DS**
Bass **ROSCOE BECK**
Electric Guitar **CHARLIE SEXTON**

NOT TOMORROW YET

Acoustic Guitar, Piano, Keyboards, Percussion, Vocals **DS**
Bass **GLEN FUKUNAGA**
Drums **RAMY ANTOUN**
Electric Guitar **CHARLIE SEXTON**
Pedal Steel **RICKY RAY JACKSON**
Vocals **JAMES HOUSE**
Loops **MARIO RAMIREZ**

TURN THE OTHER CHEEK

Piano, Vocals, Percussion **DS**
Bass **GLEN FUKUNAGA**
Drums **RAMY ANTOUN**
Acoustic Guitar **CHARLIE SEXTON**
Vocals **JAMES HOUSE**

PERFECT FOR A LITTLE WHILE

Piano, Vocals **DS**
Pedal Steel **RICKY RAY JACKSON**

THE HIGH ROAD

Piano, Keyboards, Acoustic Guitar, Vocals **DS**
Bass **GLEN FUKUNAGA / MICHAEL RAMOS**
Drums **RAMY ANTOUN**
Electric Guitar **CHARLIE SEXTON**
Vocals **JAMES HOUSE**
Loops **MARIO RAMIREZ**

LOS ANGELES

Piano, Vibes, Vocals **DS**
Bass **GLEN FUKUNAGA**
Pedal Steel **RICKY RAY JACKSON**
Harmonica **MICKEY RAPHAEL**

I DON'T WANT TO DREAM ANYMORE

Acoustic Guitar, Keyboards, Percussion, Vocals **DS**
Bass **GLEN FUKUNAGA**
Drums **RAMY ANTOUN**
B3 **MICHAEL RAMOS**
Vocals **JAMES HOUSE**
Loops **MARIO RAMIREZ**

HUMMINGBIRD

Piano, Vocals **DS**
Bass **GLEN FUKUNAGA**
Electric Guitar **CHARLIE SEXTON**

ACKNOWLEDGMENTS

THANK YOU Bale Allen, Ramy Antoun, Sharon Corbitt, Rodney Crowell, Laurel Falkenstein, Ray Foley, Radney Foster, Randall Foster at Symphonic, Glen Fukunaga, Mary Gauthier, James House, Jack Ingram, Ricky Ray Jackson, Michael Krumper and all at Missing Piece, Sean McKenna, Mickey Raphael, Scott Robinson, Haley Rushing, Charlie Sexton, Maia Sharp, Jason and Melissa Snell, Peter Williams at Agave Print, Drew Womack, John Zweig.

Tim Mathews, Kip McLanahan, Tom Mackay, Steve Rohleder, Rich Smalling, Tom and Becky Wafer, Ross Burley, Craig and Lawton Cummings, Ben Hamrick, Steve Kuhn, Mike and Lisa Pizinger, Bryan and Kristie Barksdale, Phil and Mara Fouts, Hal Peterson, Jim Ritts and Lisa Jasper, Lisa and Gene Schneider, Bill and Ana Stapleton, Deb Wylie—thank you for your support in making this project happen.

A very sustained thank you to Patreon supporters Roger Beery, Bobby Klaiss, Christian Suess, Manabu Suzuki, and Patreon Angel Supporters John Lynch, Stacy Hsu, Jonathan Mitchell.

A deep bow to Matt West and Jocelyn Bailey at Dexterity Books.

www.dardensmith.com

ALSO BY THE AUTHOR

THE HABIT OF NOTICING is Darden Smith's personal manifesto on the value of art and creativity in daily life. Using poetry and essays, drawings and photography, Smith dives deep into his inspirations and influences, the importance of commitment and endurance in tough times, and the beauty that comes from finding meaning in your life and your work, wrapping all that around stories of success, setback, and reassessment from years in and around the music business.

"What a remarkable book. An elegant gift to the world. The life lessons, laughter, love and light you poured onto each page speak volumes about the gift of seeing and listening well."
—PAUL WILLIAMS (SONGWRITER / ACTOR / ADVOCATE)

ABOUT THE AUTHOR

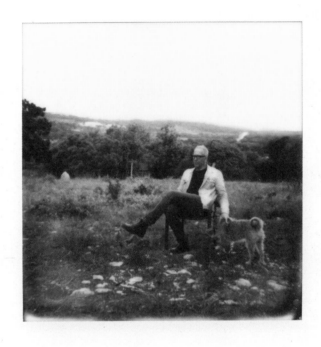

DARDEN SMITH lives in Austin, Texas, writes songs and books, and makes art. He does his best to pay attention, because the world is a very interesting place and he doesn't want to miss anything.